DRAWING *and* PAINTING

beautiful

FACES

with *jane davenport*

A *mixed-media*
PORTRAIT WORKSHOP

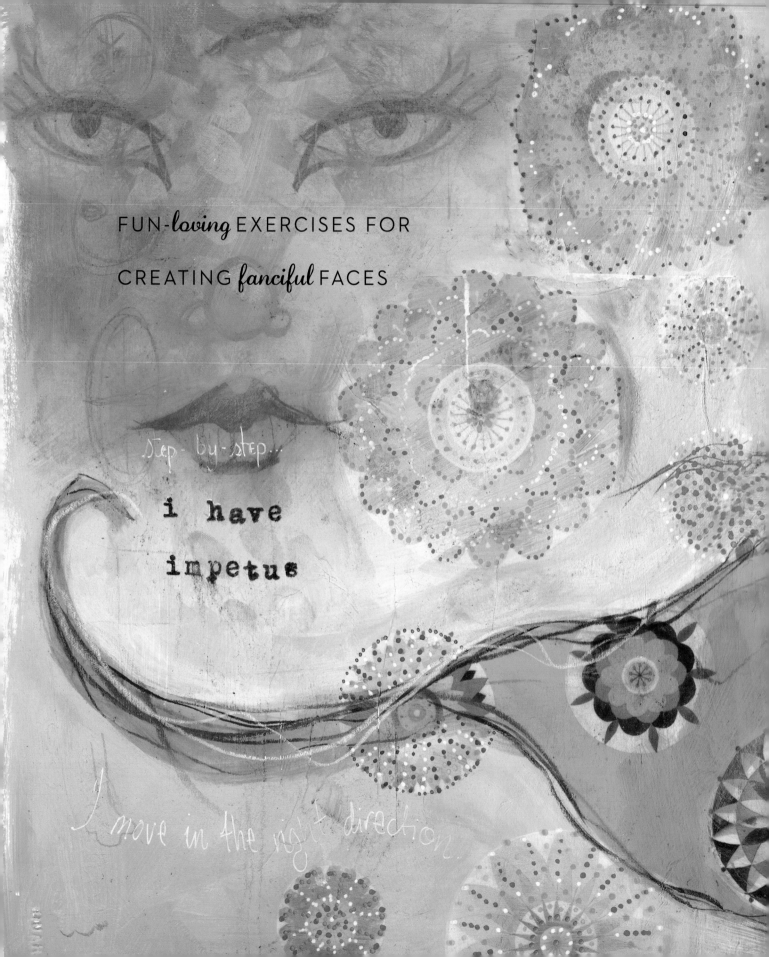

FUN-*loving* EXERCISES FOR

CREATING *fanciful* FACES

step-by-step...

i have

impetus

I move in the right direction.

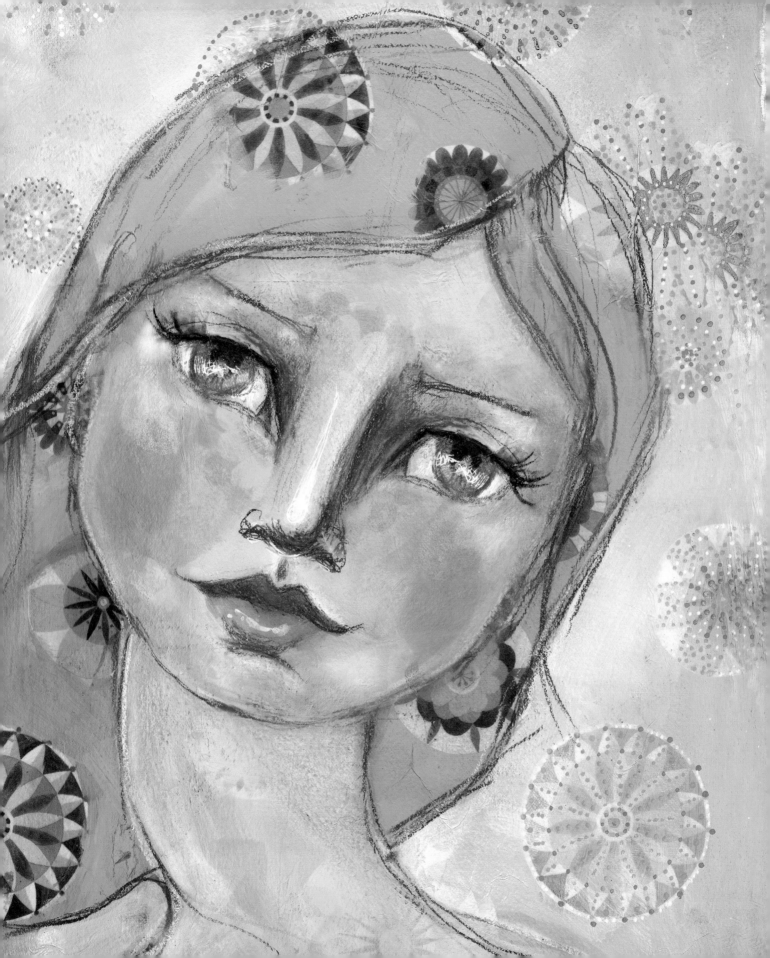

First published in the United States of America in 2015 by
Quarry Books, a member of
Quarto Publishing Group USA Inc.
100 Cummings Center
Suite 406-L
Beverly, Massachusetts 01915-6101
Telephone: (978) 282-9590
Fax: (978) 283-2742
www.quarrybooks.com
Visit www.Craftside.Typepad.com for a behind-the-scenes peek at our crafty world!

10 9 8 7 6 5 4 3 2 1

ISBN: 978-1-59253-986-4

Digital edition published in 2015
eISBN: 978-1-62788-167-8

Library of Congress Cataloging-in-Publication Data available

Design: Jane Davenport
Page layout: Megan Jones Design

Printed in China

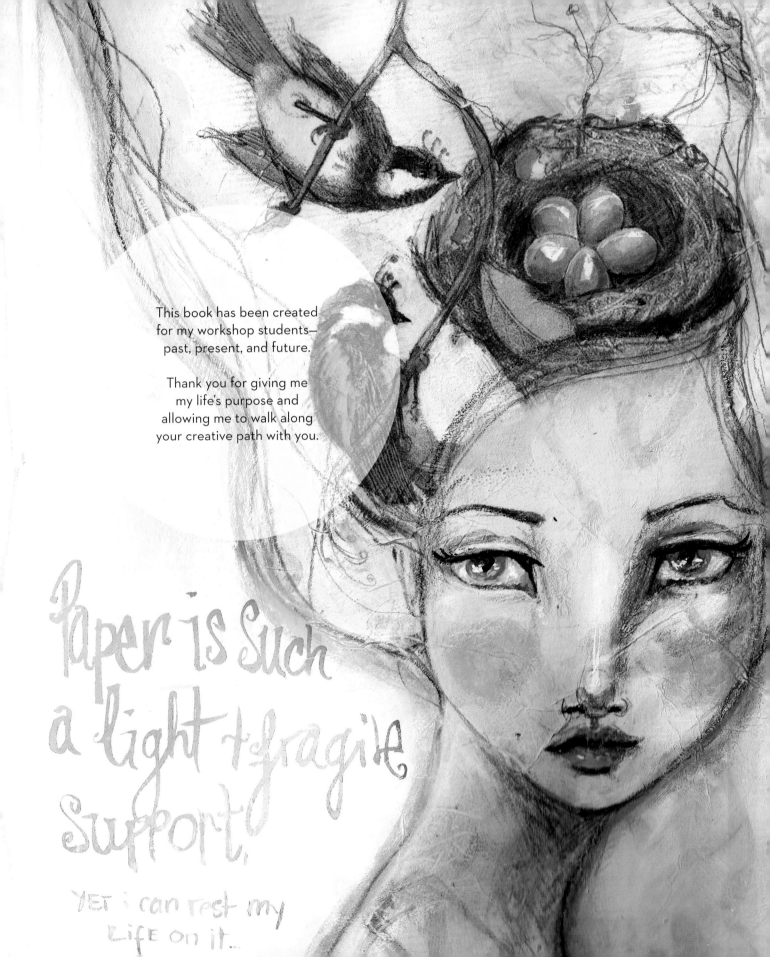

This book has been created
for my workshop students—
past, present, and future.

Thank you for giving me
my life's purpose and
allowing me to walk along
your creative path with you.

Paper is such
a light + fragile
support.

YET i can rest my
life on it...

CONTENTS

INTRODUCTION

This book is all about drawing whimsical faces from your imagination. I like to think of our pencils and brushes as harboring crowds of imaginary people and creatures—all just waiting patiently to fall out and be drawn into existence, one by one.

Drawing has long been my friend, and it wants to be yours as well. I began my drawing career as the kid-who-could-draw, then I started my first job as a fashion illustrator, and I went on to become a professional artist with my own gallery. But it wasn't until I started teaching that I fully appreciated what a **powerful** medium it is. Drawing can be the superhighway straight to the heart of your creativity!

There are absolutely no rules in art. Everything I present in my classes and in this book are simply my ideas. I believe drawing is theater. I base my artwork on reality and then heighten the elements that fascinate me until I arrive at my own style full of whimsical faces, colors, and forms. My greatest wish is for you to know the joy of drawing faces and to build your own style. And it's such a privilege to help you do that. Just follow your curiosity, gather your courage, and bravely read on!

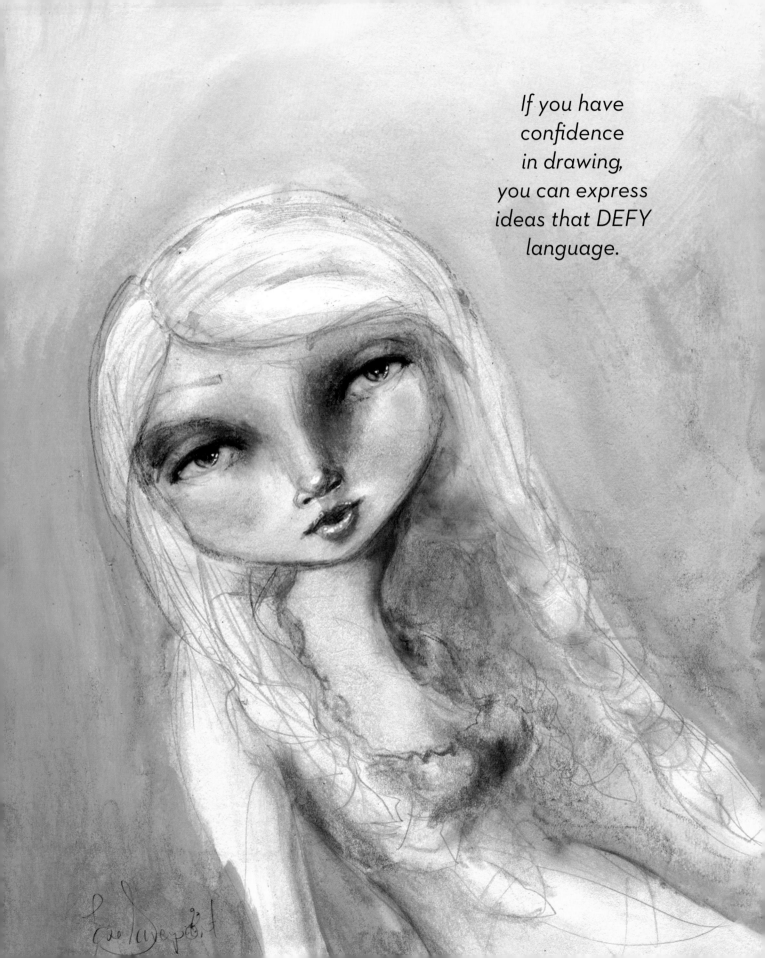

If you have confidence in drawing, you can express ideas that DEFY language.

My core desire for my students—and you are one now; welcome to the club!—is to create subtle shifts in realizing your own awesomeness and to empower you through your own creativity. I believe that feeding our artistic nature makes us better people. And the world really does need the best from of each of us!

I have taught thousands and thousands of people to welcome back their childhood love of drawing. To be part of their new creative confidence brings me untold joy. So it is with great excitement that I now usher you into my studio to share my contagious passion for drawing and painting!

Choose happiness,

jane davenport

welcome to my
STUDIO.

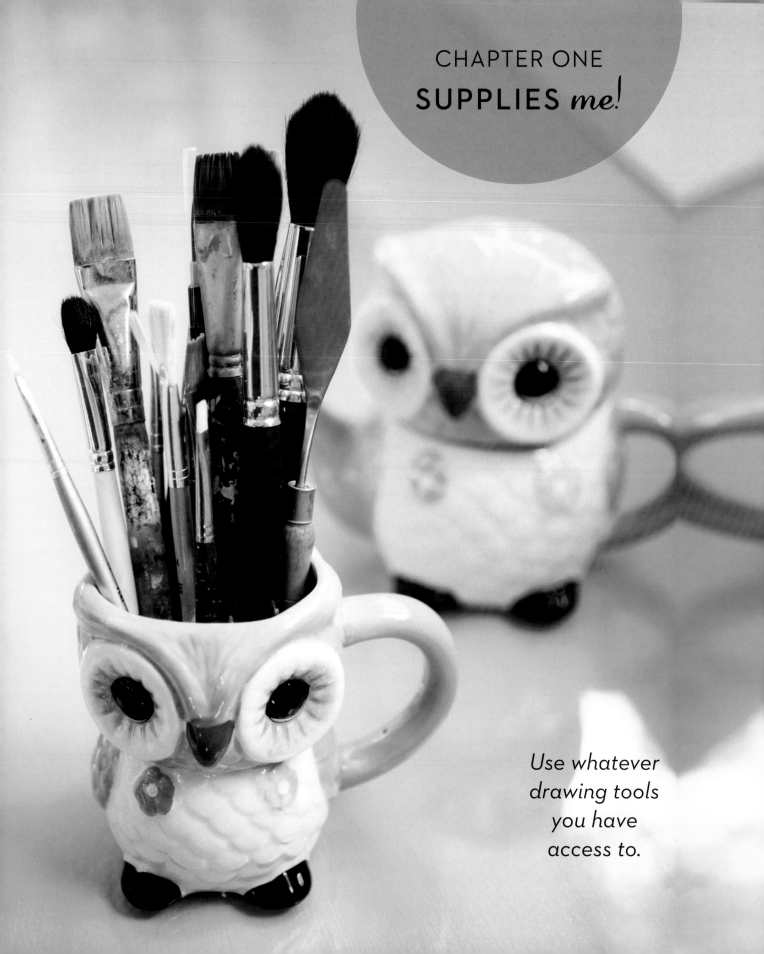

CHAPTER ONE
SUPPLIES *me!*

*Use whatever
drawing tools
you have
access to.*

"When do I use what?" is a common question about art supplies, and it's my intention to help you with those decisions throughout this book. But I have a confession to make first: I am an art supply junkie. I love art supplies so much I created an online workshop all about them and I opened an art supply store. No one knows better than I, that with all that amazing choices, deciding what to use can be overwhelming—let alone deciding how to use it.

Back to that question, "When to use what?" Well, the answer many artists give is "intuition." But what is intuition? It's the result of experience, experimentation, and practice. The important thing to realize is there are no wrong choices. There are no mistakes, no rules. Even when the result is an unexpected muddy mess, you have learned a valuable lesson about your materials.

Getting in touch with your supplies, and learning the things that make your heart sing, develops your artistic intuition. Whenever you play with your supplies, you are building your creative confidence.

I think it's important to set your supplies free from the boxes they came in and, if possible, have them arranged around you where you create. That way you can unfetter your intuition and grab whatever color appeals to you at the time!

I always have my most trusted supplies nearby to lean on, but I like trying new things, rediscovering old favorites, and experimenting to discover new ways to use what I have. Sometimes I place an ignored art supply right in front of me to encourage its use. I am not curating an art supply museum—although it certainly would be fun! I want my stuff to be paint splattered, emptied, and taken to its limits.

I call my compulsion to arrange art supplies in color-wheel order "Rainbowitis." My feeling is that the creative process is chaotic enough, so I like to surround myself with organized color while the art is happening. That way I can always (well, usually) find what I need.

In this chapter we take a closer look at the materials I use in my artwork.

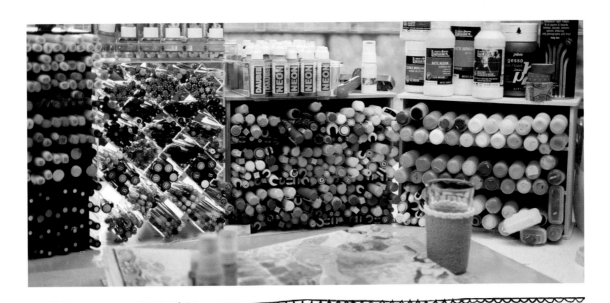

SURFACES

Making art is a physical experience. So much inspiration comes from the way it actually feels to put our tools to a surface we like. I, for one, go crazy over great paper! So although this book's exercises can be created on canvas, wood, panels, or the walls, I encourage you to consider dedicating a sketchbook to them.

ART JOURNAL

I am a huge fan of art journaling. This practice combines a sketchbook, notebook, diary, and scrapbook into a field book of your life. It is just for you, so anything goes! It's so nourishing to create in something you can open, close, and carry with you. In most of my workshops I have my students working in journals because it removes so much pressure. Don't like something you just drew? Just turn the page and work on something else.

Give yourself some room to create. The 8" x 11" (20.3 x 28 cm) Strathmore 500 Series Mixed-Media Hardbound art journal is my favorite commercially available sketchbook. Even better, you could make your own journal. For instance, I made a 11.5" x 13.5" (29.2 x 34.3 cm) journal to create all the lessons in this book.

My favorite paper is Fabriano Artistico Hot Press Watercolor in 140lb (300 gsm). It is robust, smooth enough for collage, loves all mediums, doesn't buckle, and folds like a charm. A quick internet search will turn up great instructions on basic journal binding.

BRUSHES

I think this is a very personal choice for every artist. I prefer to use the following:

- synthetic bristles, as they have more bounce
- acrylic-handled brushes, as they have more weight in the handle and last longer
- angled brushes of all sizes to paint my details
- a waterbrush for fine details and lettering, as they are hollow and can be filled with ink

Take care of your brushes by not leaving them in water overnight. Instead, clean and dry them and put them away bristles up after each creative session. Every so often you can treat them to a soak in some brush cleaner and restorer.

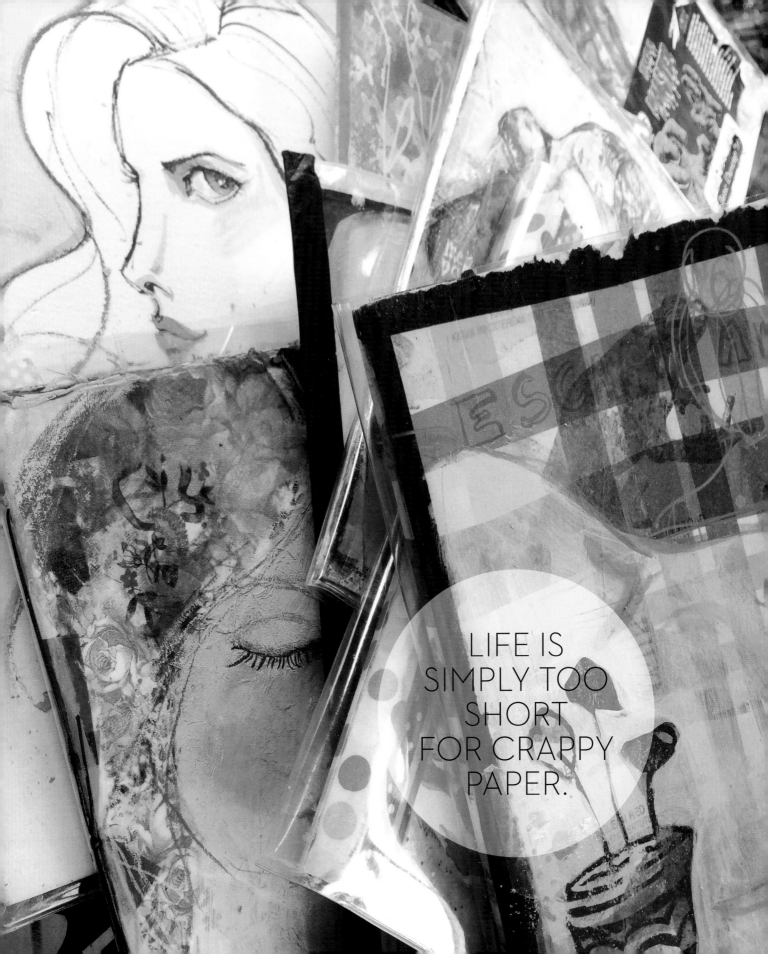

LIFE IS
SIMPLY TOO
SHORT
FOR CRAPPY
PAPER.

GESSO

Gesso is pronounced *Jess-oh* and is used to prepare your surface for paint. I love working on a gessoed surface because of the way it feels under a pencil or brush. Gesso strengthens thin and porous paper. It is brilliant for working in altered books, which is one of my favorite ways to work.

Generally, I apply one coat of gesso, wait for it to dry, and then decide if I need to add another coat. If I want it smooth, I give it a light sanding, but I love the texture it gives the page, so I usually leave it.

I also use gesso as white paint to transfer images and as an eraser to cover up words, add layers, and generally make a lovely arty mess! Some brands have a lot of grit and are too rough, in my opinion. Others dry very shiny and plasticy, which makes them hard to work on. There are many brands, but I rely on Liquitex because it's smooth, making it lovely to write and draw on. It is perfect for layering, which is essential to the way I like to work.

GESSO TIPS

- Designate a paintbrush just for gesso because it's tough on your brushes. A synthetic bristle, large, flat brush for acrylics is perfect.
- Don't paint back-to-back gesso pages in your journal without letting them dry in between. The outer layer of gesso will dry quickly, potentially trapping moisture and weakening the paper.
- Experiment with application. Try using a wet brush (creates a milky layer), a dry brush (for more yummy texture), or a credit card (delivers a very smooth surface).
- You can sand gesso to create an eggshell-like surface.
- Use masking tape in the spine of your journal and gesso over the top of it to prevent paint leaking through the binding holes.
- Shake your gesso before you open it, as the ingredients will settle over time.
- I find gesso cures better if left to dry naturally rather than cooking it with a heat gun, but if you are in a rush, a heat gun is a wonderful tool.

Replace NEGATIVITY with Creativity

PAINT BEHAVES BETTER ON GESSO.

ACRYLICS & MEDIUMS

There is something magic about acrylic paint. It just feels so good to swoop it across the page or canvas. I prefer matte paints because they are receptive to pencil, watercolor, and markers, and they allow you to work in layers with mixed media. The wonderful news here is matte or craft paints are usually inexpensive and nontoxic. They come in a wide range of colors and are readily available. Ceramcoat by Delta, Americana, and Adirondack Dabbers are the brands I recommend for the techniques in this book, but any matte acrylic paint should be fine.

Acrylic comes in many forms too, from the heavy-body paints to super-fluid inks and spray paint. It even comes in pens! Paint pens and markers are a super-convenient way to carry and use acrylics. You can get by with a basic color selection to create any hue, but I prefer to use premixed colors. It helps me with my decision making, and it gives me a head start with mixing new colors.

MEDIUMS & GROUNDS

Mediums are like acrylic paint without the color pigment. They usually look milky in the container, but dry clear. Most are fluid and applied with a paintbrush. There is a whole world of mediums for the artist to explore, each with different properties.

The medium I use most is fluid **Matte Medium,** and it's essential for my daily living. It can be used as a glue, glaze, varnish, and transfer medium. It looks milky when you apply it, but dries absolutely clear. I swear by Liquitex Matte Medium. There's no affiliation, just total affection!

Shiny, satin, and glossy mediums are difficult to draw and collage on, so I suggest you save anything that threatens to dry with a shine until the final layer.

A **ground** is used to create an absorbent, primed surface on which paints will properly bind. Grounds are usually white and come as a paste that can be applied with a palette knife.

Fiber Paste is an example of a ground. It can create a rough watercolor paper on any surface. It looks a little like a very fine paper mâché in the container. Spread it over your surface with a palette knife and let it dry overnight. It works like magic with acrylic inks and watercolors.

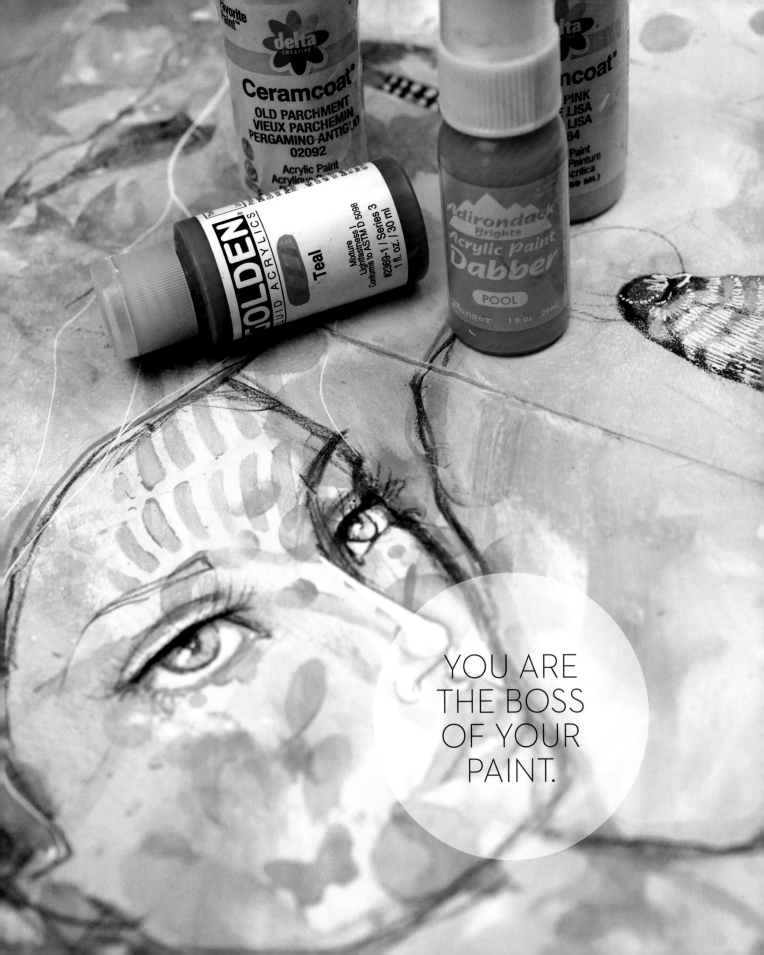

YOU ARE THE BOSS OF YOUR PAINT.

PASTELS

Pastels are vibrant, free-spirited art materials, and I like to think that those qualities are reflected in artwork created with them.

Pastels come in a wide variety of forms from chalky sticks to pencils, water-soluble Gelatos, and oil crayons. They are not built for precise, detailed work. They are all about intuitive color, marks, and play.

If you are feeling stressed, don't know what to draw, or where to start on a page, grab a pastel! Your hand will remember the crayons you probably played with as a kiddo . . . and then just start moving around on the page. Don't think! Just play with the pure colors and the magic way you can blend them together.

If you want to get your pastels really singing, give them a rough surface to grab onto. You can use a pastel paper that has 'tooth' or apply a **pastel ground,** which is a paste that contains grit.

PanPastel Colors are a particularly liberating and fun form of pastel. Officially, they are named after their pan makeup appearance, but I like to think they are named after Peter Pan because they bring out the inner child, which is always a great way to loosen up and enter into your creative flow.

Pastels only have one drawback. All those free floating pigments need to be fixed in place with a spray fixative. Always use fixative as per directions in a well-ventilated area.

I usually apply a **Workable Matte fixative** several times. A few light layers are better than one heavy application. This type of spray allows you to keep working on your art and create layers of color that don't mix with each other. When you are finished, you can use a permanent fixative to set everything.

Once dry, I use Liquitex **Matte Varnish,** a super-fluid, clear liquid that protects and seals artwork. It creates a lovely patina and feel.

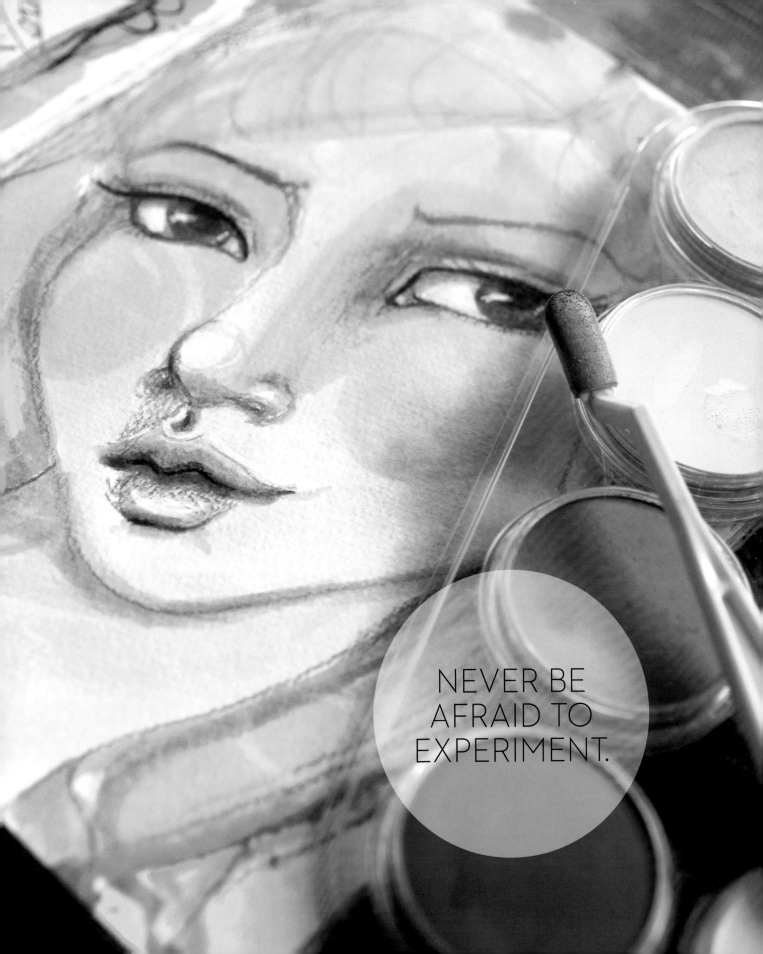

NEVER BE
AFRAID TO
EXPERIMENT.

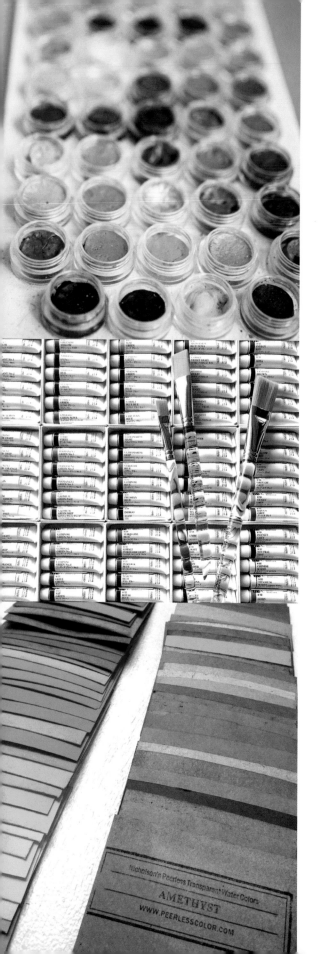

WATERCOLOR

Watercolor has a mind of its own and that is exactly what makes it so enticing to use.

As a mermaid at heart, I absolutely love watercolor because it is liquid and goes where it wants to. Most other media just sit exactly where they're placed, but watercolor moves like a living thing and each stroke does amazing things on its own while drying. Like the ocean, you can't tame watercolor, you just have to learn to put yourself into that energy and ride along with it!

When you hear "watercolor," you may think of the type that comes in a tube or pan. But watercolors come in a delightful variety of forms. Peerless are my favorite because I can carry them with me wherever I go. Concentrated color is painted onto a special film that you can cut and use in small portions. It's perfect for travel!

I like to think of my Peerless Palette as a rainbow in my journal! In the main picture opposite, you can see the one I made from my signature edition of these unique watercolors.

No matter what type or brand of watercolor you use, they are all fun. They will help you create either bright and vivid, or soft and ethereal artwork.

Try a very wet brush to draw up the color from the palette. In a good-quality watercolor, a little bit of pigment can go a long way. When you first lay down the color, it is intense. As the pigment drains from the brush, it becomes less and less so. As watercolor dries the colors usually become lighter. So I tend to overdo the color a little, as I know it will change.

One of my favorite ways to use watercolor is over a sketch done in waterproof pen. The paint contrasts with the pen in a delightful way. The messier and looser you make the brushstrokes, the better. You can start with the watercolor and add the pen for details later, or add the watercolor on top of the sketch.

A swish with a watercolor brush and you've got absolute magic. You can create unique, spontaneous, loose, and splashy faces with sparkle!

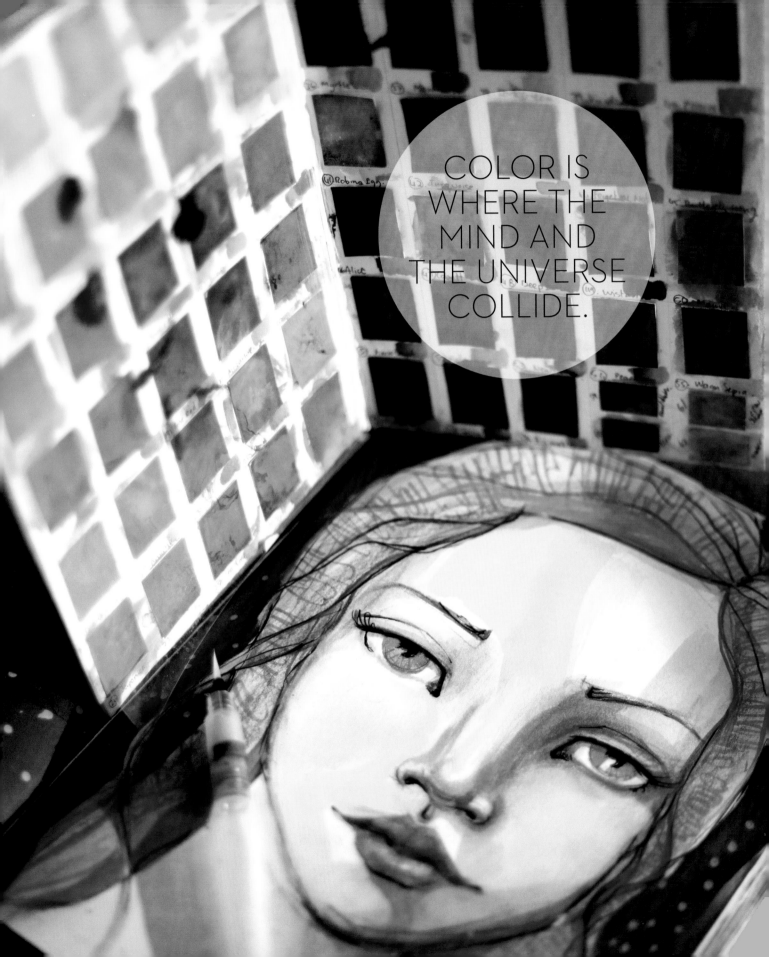

COLOR IS
WHERE THE
MIND AND
THE UNIVERSE
COLLIDE.

PENCILS

I think of colored pencils as magic wands. I just wave them at my paper and lovely things happen. I love to start my artwork by using colored pencils as a sketching tool and finish with them for the details.

PRISMADONNA

There is one colored pencil (a.k.a. CP) that rules over all others: Prismacolor Premier. They lay down their incredibly vibrant pigment with ease. I have been dubbed a "PrismaDonna" because I am so obsessed with their qualities! Many of the techniques in this book are optimized if you use these pencils.

Prismacolor pencils must be babied though. They are delicate creatures. A blunt sharpener, a fall, or even a dirty look could crack their soft core into a dozen tiny shards. If this happens, I just pick up the little stub, stick it back in the pencil, and continue on.

You can build up colored pencils in lots of light layers rather than one heavy application. If you color in a circular motion, you will avoid streaks and get much smoother results. I will also show you some heavy blending techniques in this book which give porcelain-smooth, luminous skin tones.

NO GRAPHITE

I rarely use graphite to draw with and I encourage all my students to give up the lead, at least for my classes. I use a colored pencil to draw with **because it is difficult to erase.** This way you have to learn to live with your marks, instead of erasing. I believe erasing can bring out the perfectionist in us, and it's hard to enjoy the process if you are constantly judging your work.

If you are addicted to your eraser, consider using a **Col-Erase** pencil. It's a favorite with animators because it draws so smoothly.

CHINA MARKERS & ALL PENCILS

These unusual pencils will write on just about anything. I consider a black and white in each to be essential for creating the whitest highlights and darkest shadows on a face. **China Markers** (a.k.a. Chinagraph, grease, nerd, or wax pencils) form rough lines as a finishing touch. **Scribe-All Pencils** are very similar, but are water soluble as well.

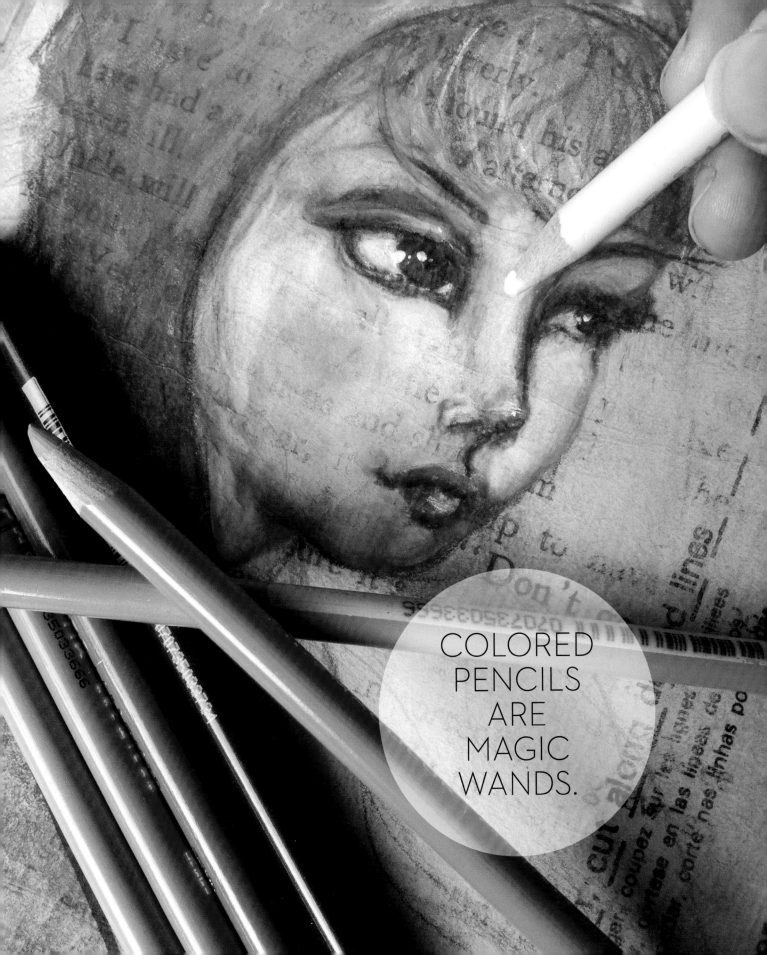

COLORED
PENCILS
ARE
MAGIC
WANDS.

INK

Ink is quite the chameleon! It also comes in a great variety of formulations, but I split them into waterproof and water reactive.

I mainly use waterproof inks because once they are dry they can be layered on top of each other without further mixing. Because I work gradually on each artwork, with days or weeks separating layers, I forget what I may have used. It can be a bit alarming when a solid-looking lash line suddenly activates as I'm painting and then spreads across the face!

INKY BUSINESS

I love to load my inks into a waterbrush—a hollow-handled paintbrush that is usually filled with water for watercolorists on the go. But they also make the most divine brush pens in the universe (you can see some examples in the photo at right). My favorite is Pentel's Aquash. I use the fine tip for writing, the medium tip for drawing, and the broad tip for my Peerless Watercolors.

Not all inks are fine enough to feed through the waterbrush mechanism, but you won't know until you try. All you do is open the waterbrush and use a medicine dropper to transfer the ink. You can create your own colors, too. Don't forget to label your new pen with what is inside so you can refill it.

FAVORITE INKS

I almost cannot leave my house without my set of Dye-Na-Flow inks in Aquash waterbrushes. The colors are inspirational, permanent, and dry quickly. I do a lot of drawing and most of my journaling with them. Writing and drawing with a waterbrush makes me slow down, so what I write, and the way I write, become more meaningful and beautiful to me.

Liquitex acrylic ink in black and dark umber is perfect for creating eyelashes and fine details in faces.

Another favorite is the Hero Arts Dauber ink in Neon. A little touch of neon adds spark to a whole page.

I use ink over pencil and paint as a way to add subtle color to shadows on a face, bringing life to it.

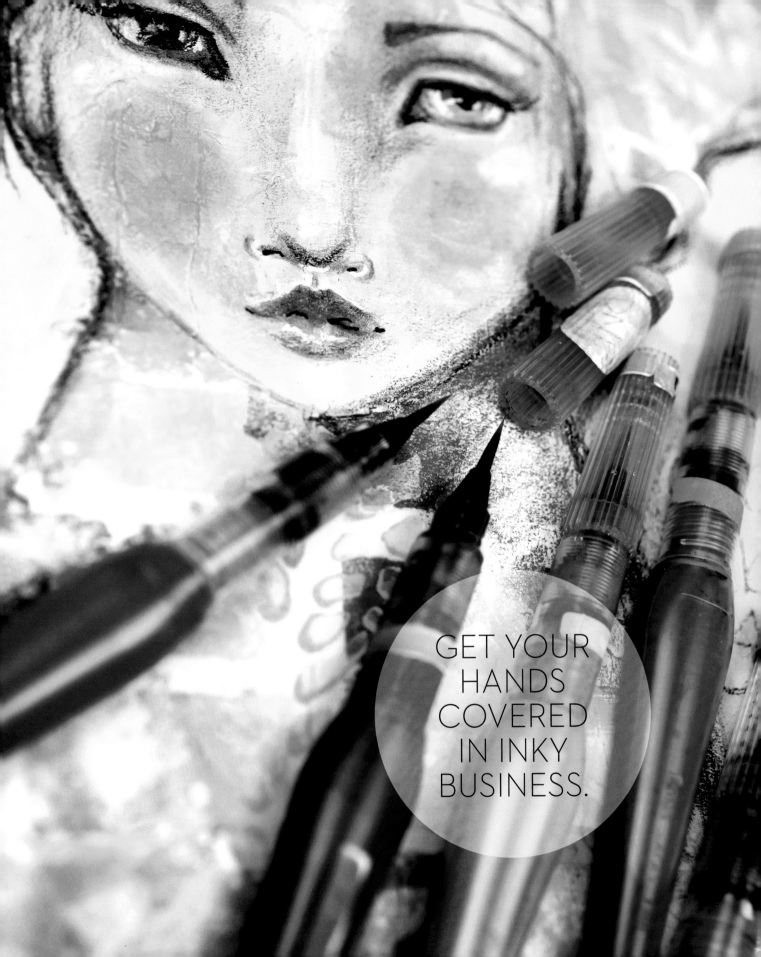

GET YOUR HANDS COVERED IN INKY BUSINESS.

MARKERS

Markers have been a longstanding passion of mine. As a fashion illustrator, I learned to rely on them because they are a quick and tidy way to add color. The two types of marker I use in my artwork are watercolor markers and alcohol markers.

The secret to them is in the paper you use.

For alcohol markers, such as Copic, a bleed-proof paper or blending card is ideal. These special types of paper allow the alcohol-based pigments to spread into the paper fibers, giving your work soft and feathery edges. If you use normal paper, the ink shoots straight through it and onto the next page—or worse, the table!—and you end up with a streaky mess.

For **watercolor markers,** such as Tombow Dual Brush, a smooth watercolor paper is an ideal choice. Resist rubbing away at the paper, as that will likely result in the surface lifting into little crumbs. Instead, apply the markers with a calligrapher's grace.

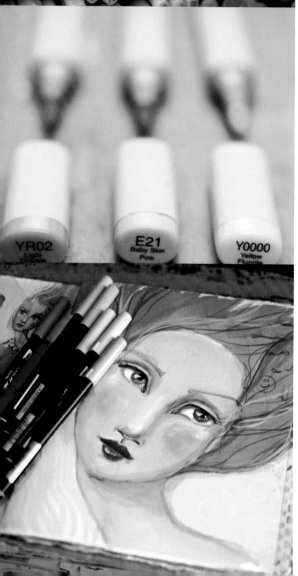

You can also use either of these markers on top of matte paint, gesso, watercolor, or colored pencil. When they are used on other mediums, their effects can be quite subtle, so they are wonderful for adding depth to shadows and subtle glints of color in eyes and lips.

Alcohol markers are capable of dissolving colored pencil and acrylic paint, so you can use them to blend those materials. Just make sure to clean the marker nib after using it or it will clog up with the waxes and paint.

You can also apply alcohol markers over watercolor paint and markers, and vice versa. This is especially useful because alcohol markers are one of the only things that will not make water-soluble paint and markers react. I love to use alcohol and watercolor markers together in layers, as their inks won't react with each other.

Both types of marker are available in colorless blenders, which can be used to soften edges and move color. Markers are not lightfast, so it's best not to display or sell your originals. They will be fine in an art journal. Scan and display prints of your marker-based work instead.

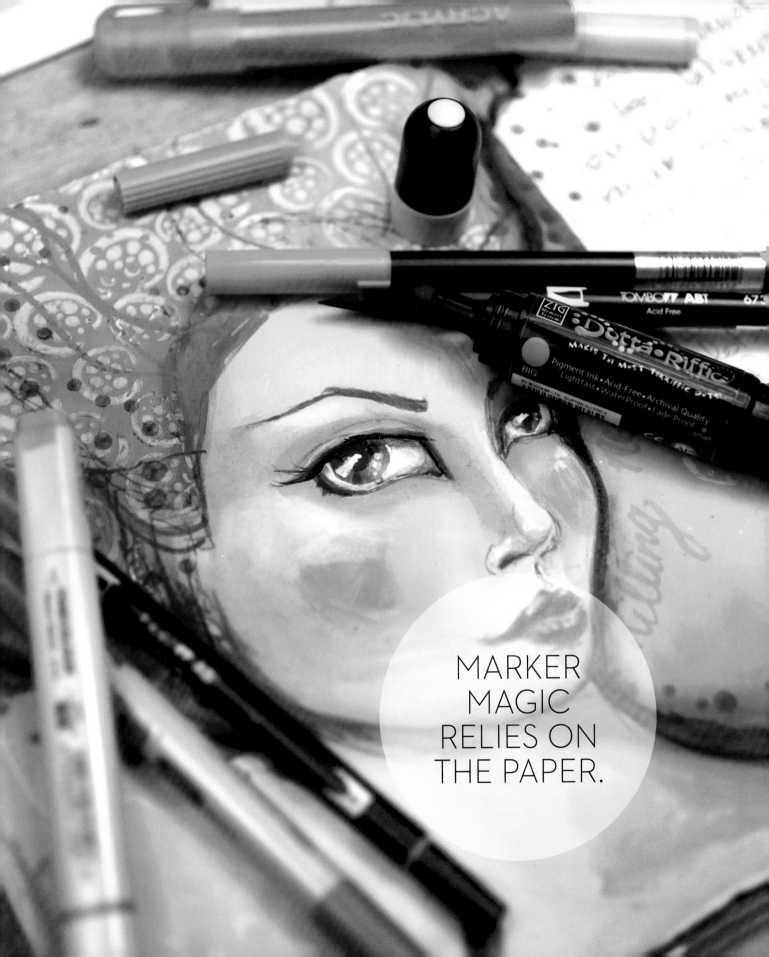

MARKER
MAGIC
RELIES ON
THE PAPER.

PENS

Nothing beats a pen for getting an idea down quickly. I think they are terrific tools for sketching because they have a finality to them. There's no erasing. The whole history of the drawing is there. The looser your lines, the better your sketches look. Very often I try to re-create a pen sketch in finer materials, and I can never quite capture that original, free essence of my pen sketch.

There are so many pens! I encourage you to find your favorites. Here are some of my recommendations:

- The trusty Sharpie Pen in fine is probably the pen I use most. It is robust, dries quickly, and is waterproof. Not just that, it can stand its ground with alcohol markers, too.
- Micron pens from Sakura are wonderful and come in very fine tip sizes. Micron pens have all the same qualities as the Sharpie Pen, but I find them to be far more delicate. They don't like texture or working on paint, but they are perfect for working on paper with watercolor.
- The Uni-ball Signo Broad is a white gel pen that loves writing on most surfaces—including washi tape, which few pens can do!

PAINT PENS

Paint Pens are brilliant! The ink in them is a thin, acrylic paint that is excellent for writing, quickly blocking in color, and creating details. They are fun, creative, and convenient. There are many brands, but my favorites are as follows:

- Sharpie Poster Paint Marker: Look for the water-based acrylic rather than the oil-based, which are usually smelly and dry with a shine. If you ever meet me without an extra-fine point, white Sharpie in my hand, you are looking at an imposter.
- Montana Acrylic: These are highly opaque, quick drying, lightfast, waterproof, have a matte finish—and are thus everything I look for in an art supply. They are refillable, so you can mix your own colors. I like the fine 2-mm and wide 15-mm tips best.

Remember to give your paint pens a really good shake with the cap on before you use them.

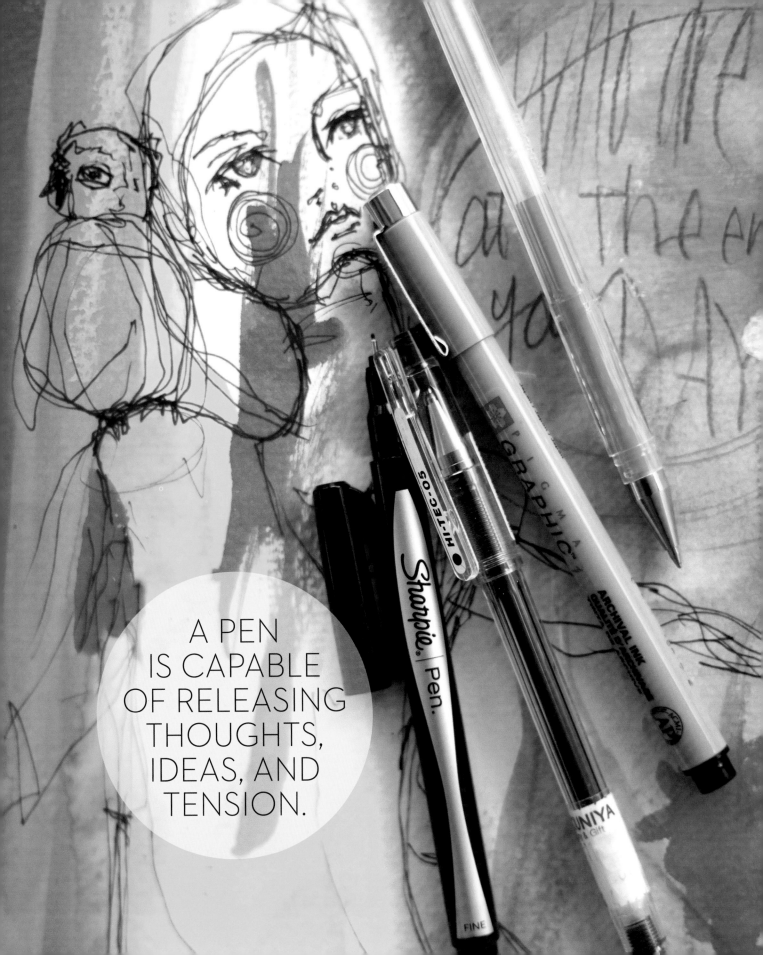

A PEN
IS CAPABLE
OF RELEASING
THOUGHTS,
IDEAS, AND
TENSION.

STENCILS

Stencils are idea generators. They are superb for straight-out creative experimentation and fun!

For a start, you can use stencils to help you create intricate and interesting backgrounds quickly and easily. They help take you on a journey every time you create with them because you get to audition your ideas before you commit. They can also help keep that sense of play in your artwork.

You can make your own stencils using thin plastic from packaging (a great way to recycle), or look at the wide range of stencils created by artists. When I created my first sets of stencils with Artistcellar, it was in direct response to what I thought would help my students the most as training wheels. I designed face forms based on my own artwork and the principles in this book. What I have discovered through my teaching is that when we start drawing we tend to err toward wanting to be perfect straight away. Even though we know it's completely unrealistic, the expectation is there! My Jane-Girl face stencils give symmetry to your drawings and offer a base for students to grow without self-criticism.

Even though I can construct a face from scratch, a stencil allows me to get what's on my mind flowing freely. Sometimes I want to catch ideas, memories, and notions as quickly as possible, get them on paper, and move on. I use stencils to speed that process along.

You can trace through stencils with a pencil or spray ink through them. You can spray-paint over them, dab paint, and use pastels. One of my favorite ways to use stencils is with a waterproof stamping ink and a Colorbox Stylus. The stylus has a foam tip that pounces over the stencil. It gives a subtle, stippled look.

Another fun way to use stencils is to apply modelling paste (also called texture and moulding paste) through the stencil with a palette knife. You can mix acrylic paint with the paste to color it, too.

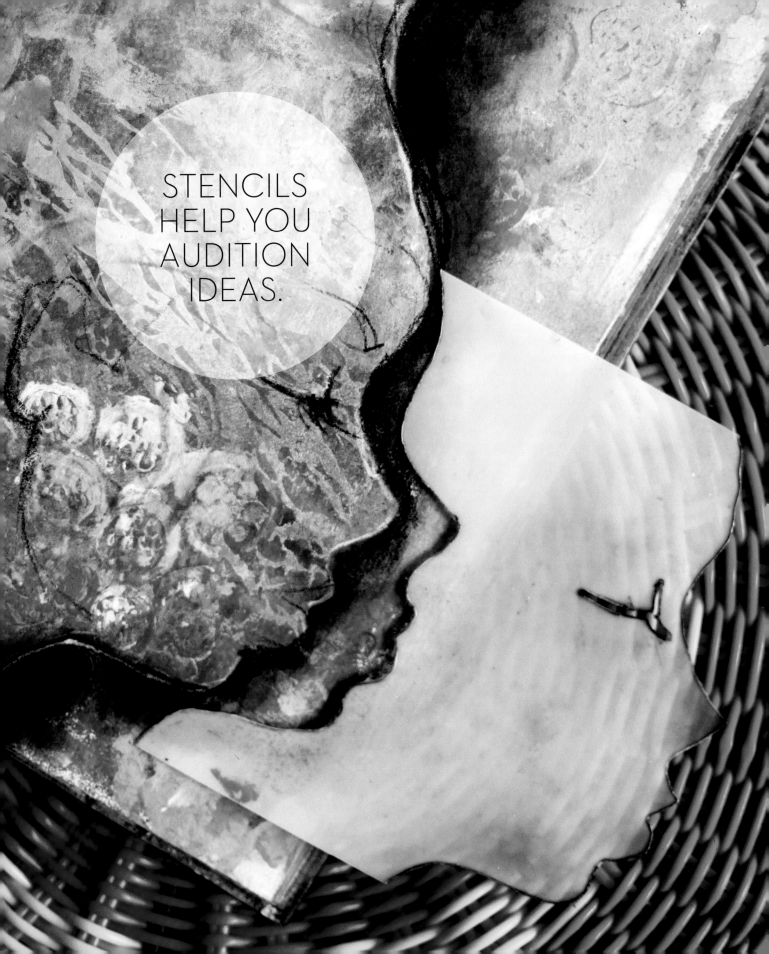

STENCILS
HELP YOU
AUDITION
IDEAS.

EPHEMERA

I love my stash of papers, feathers, fabric, tapes, and maps.
Whenever I go for a little rummage in my collection, I find inspiration and ideas calling me from every page. Ephemera is defined as "things that are used or enjoyed for only a short time." But in an artist's hands, they can be enjoyed in perpetuity!

PAPERS

Pages from old books that are falling apart, pretty scrap papers, maps, old certificates, report cards, homework from school, vintage wallpaper samples, postcards, movie posters, record album covers . . . these are all wonderful backgrounds for your art! You may need to strengthen old papers with matte medium or a gesso wash before using them.

I am always on the lookout for old maps and atlases. Especially if the places they portray hold meaning for me. Maps make wonderful backgrounds for artwork and as collage elements.

TAPES

I consider cream-colored masking tape an essential art commodity. I use it when I am altering old books to strengthen the spine. Printed washi tapes, originally from Japan, are for wrapping gifts. They don't have much sticking power, but one can easily overlook that because they are so cute as collage elements and when used to repair tears in paper.

PAPER NAPKINS

I may have the world's largest printed paper napkin stash! I get sent them from all over the world (hint, hint). Once you remove the white backing tissue, you have a very fine printed layer that dissolves to nothing when you apply it to your page with matte medium (both under it and over the top) to form a protective barrier. Keep any tissue paper you come across from packaging and gifts. You can apply it the same way as paper napkins.

COLOR COPIES

Color laser prints are fantastic for collage. I like to copy my own artwork onto the thinnest paper I can to use as collage elements.

THEY
JUST
MAKE ME
HAPPY.

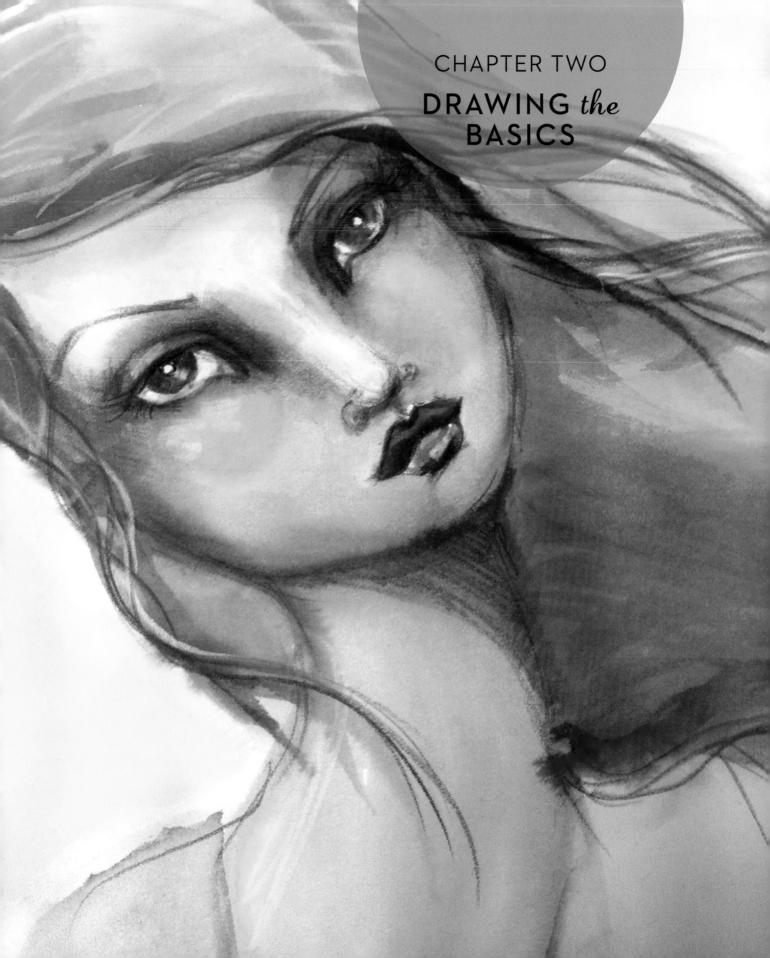

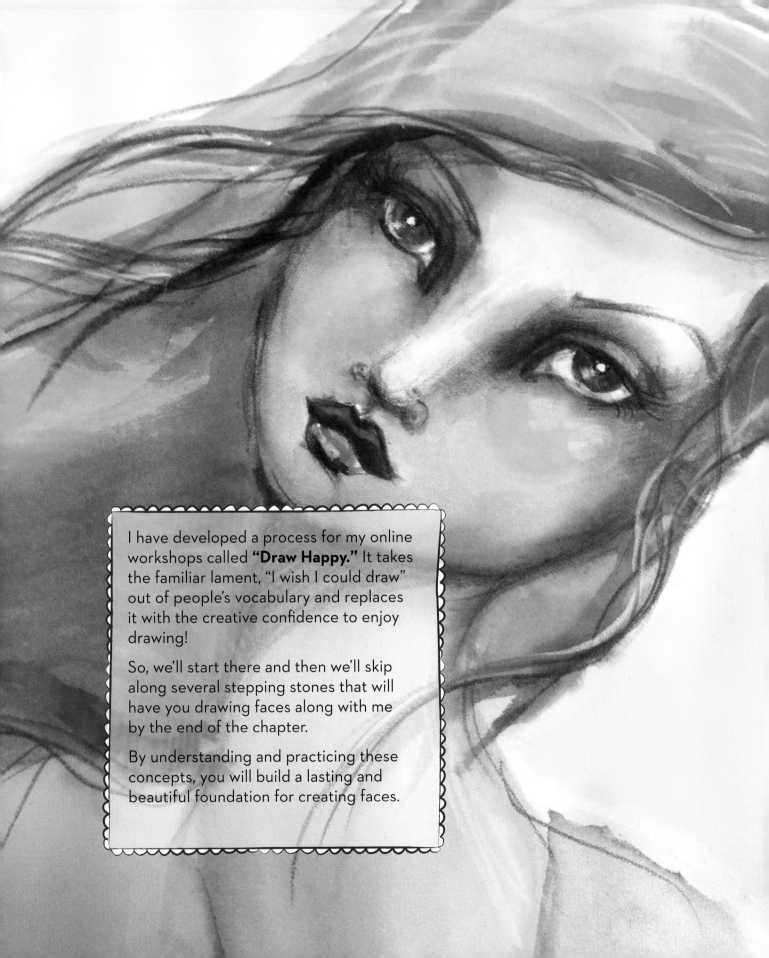

I have developed a process for my online workshops called **"Draw Happy."** It takes the familiar lament, "I wish I could draw" out of people's vocabulary and replaces it with the creative confidence to enjoy drawing!

So, we'll start there and then we'll skip along several stepping stones that will have you drawing faces along with me by the end of the chapter.

By understanding and practicing these concepts, you will build a lasting and beautiful foundation for creating faces.

DRAW *happy*

Faces are regarded as difficult to draw because we are just so familiar with them and can spot "flaws" so quickly.

In this illustration of my face, you see how much detail can be removed and you can still recognize me. To start drawing a face, all we need are the major landmarks of eyes, nose, mouth, and the head shape.

Forget about trying to create a masterpiece. All you need do is draw along with me and let your innate knowledge of facial features guide you. Follow the steps on the next page to create a simple, little **"Draw Happy"** face.

The trick is to work small and not worry yet about exact proportion or expressions. We are going to learn those details later. Draw as many of these little faces as you can before turning the page. In my online classes, I have seen students fill books with them. And you know what? They progress faster, with more confidence and happiness! Take the time to practice. Your skills will improve.

Smile as you draw, as that's where this style of face gets its name. (And it really does help.)

SOMETHING TO TRY

A "DRAW HAPPY" FACE

1 Start with a small oval. Two little arches mark the eyes.

2 – 4 Add a little downward dipping curve for the nose and little lips.

5 Loose lines framing the face will do for hair.

6 Ears are simple curves on either side of the face.

7 The neck flows from either side of the chin.

8 Simple eyebrows can be added above the eyes.

9 – 10 Connect one eyebrow to the nose with a lightly drawn line.

11 – 13 You can add more detail to the eye by adding the iris and eyelid crease.

14 – 15 Make the lashes and pupil stand out by using a black pen.

16 A touch of white pen in the pupil gives a twinkle to the eyes.

17 – 18 Add some depth by shading the top lip and the hair that falls behind the neck to show it is in shadow.

19 To finish, you could give a blush to the cheek and lip with a rosy color.

20 Add some color if you like!

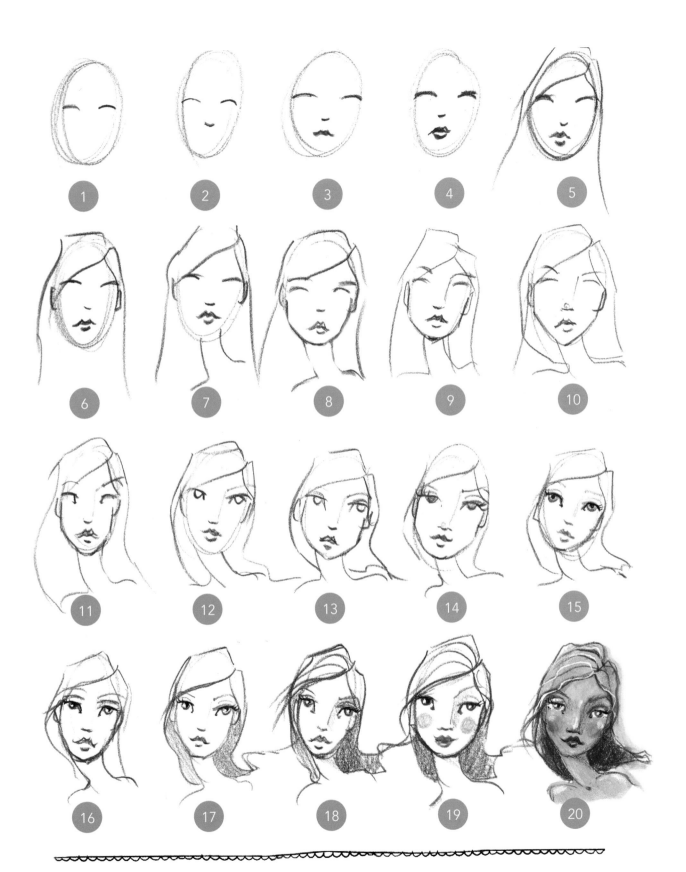

DIVIDE & CONQUER

Use **Guide Lines** to help you place features on the face with confidence.

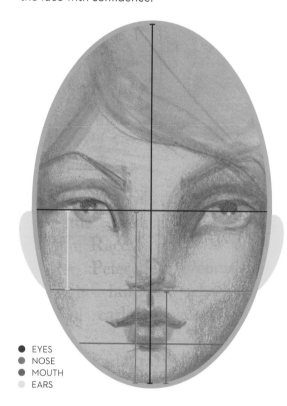

- EYES
- NOSE
- MOUTH
- EARS

- **EYES** are about halfway between the hairline and chin.
- The bottom of the **NOSE** is about halfway between the chin and eyes.
- The **MOUTH** is about halfway between the nose and chin.
- **EARS** sit between the eyes and nose.

Take a pencil and line it up under each of your own features to see this for yourself.

ALL SORTS

Of course there is a huge amount of variety in every face. These guides will work on any face shape. You can decide where to place each feature to give your drawings unique qualities.

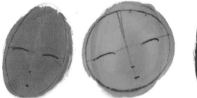

Amazingly, these guides work on any face shape.

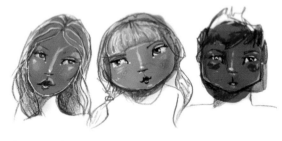

If you stick to these basic placements of the major features, the face will look balanced no matter what face shape you draw.

Create a series of different shapes. Then draw on some simple faces and see for yourself!

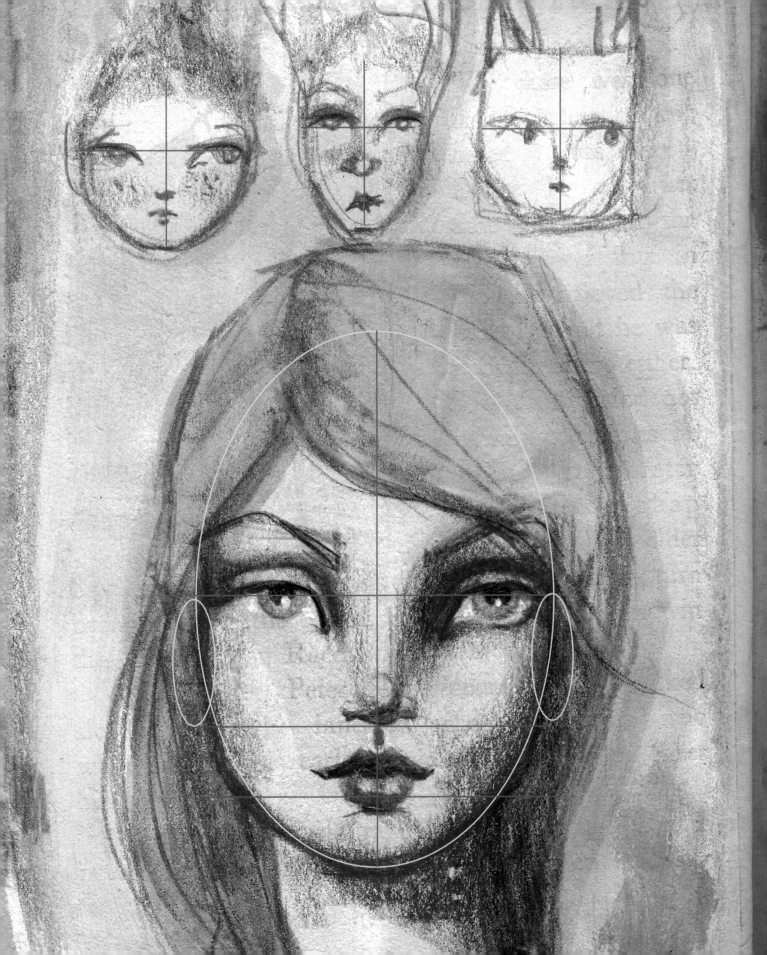

grand SCALE

When you create a small and simple **"Draw Happy"** face, you don't need to worry about details. But as you scale up, the shape and placement of features begin to matter. In chapter three, we will go through how to draw each of the features in detail, but first you need to know where they all go.

I like to draw using soft-core colored pencils, and I recommend you try them as well. Graphite pencils are easy to erase, but I want you to allow yourself to make mistakes and keep on drawing regardless!

START WITH AN OVAL

1 I start each drawing with a big, light circle. I keep my wrist loose and just see who "falls out of the pencil."

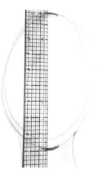

2 Next, I start placing **Guide Lines.** I define the top and bottom of the circle (i.e., the lowest part of the chin and top of the forehead). I lightly draw in a vertical line with a ruler and check to see that each side of the oval is even.

3 The next **Guide Line** is horizontal and sits halfway down the face. I check that each side of the oval is about the same width and an even shape.

4 To mark the eyes, start with two arches on the horizontal **Guide Line.** On the vertical **Guide Line**, mark in the bottom of the nose, which sits approximately halfway between the eyes and chin.

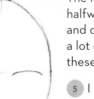

The mouth sits about halfway between the nose and chin. (You can have a lot of fun playing with these proportions later!)

5 I keep the pressure on my pencil very light by holding the pencil loosely near its end. I prefer to make a darker mark on the page by building up the strokes, rather than applying a heavy hand at this stage.

For now, I want you to feel the texture of the paper through the pencil and enjoy the experience of bringing someone who only exists in your imagination to the page.

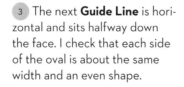

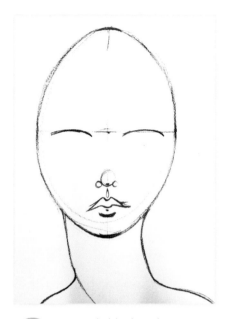

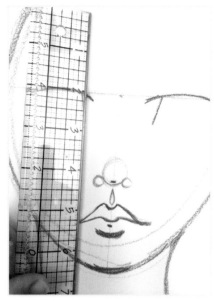

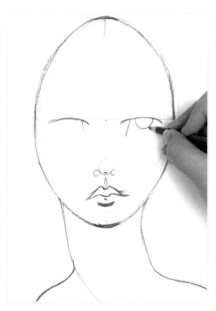

① Loosely block in the nose and lips by using their simplest shapes.

② Measure from the corner of the top lip to place the corner of the eye.

③ Work on the details of both eyes at the same time, going back and forth between them.

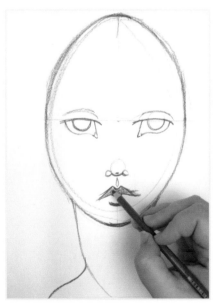

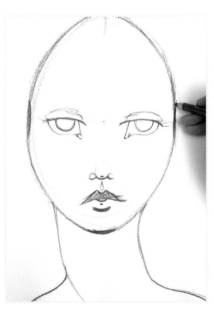

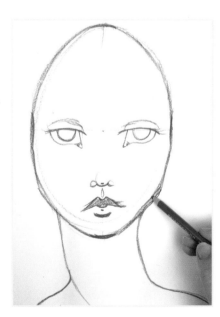

④ Softly shade in the top lip to add some instant volume to the mouth.

⑤ To shape the face, start with contouring the temples in a little next to the eyes.

⑥ Add some shape to the jawline and chin, trying to keep both sides even.

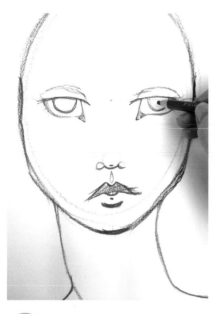

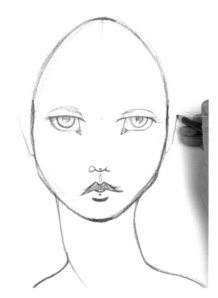

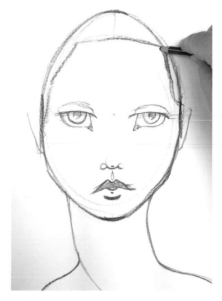

7 Start on some details. Add pupils and leave a highlight shape.

8 Ears are easily forgotten, but a face needs them to look balanced. Start them near the tip of the nose and go up.

9 Pencil in the hairline. Look at your own in the mirror and note the angles.

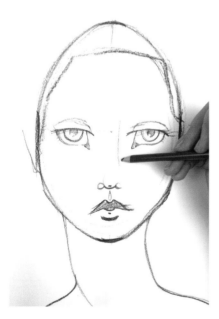

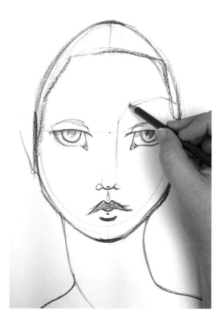

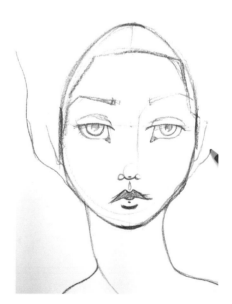

10 Building the nose consists of adding the arch on the shaded side of the face.

11 Come up and over the eye to form the brow bone and eyebrow.

12 Keep hair lines loose and free, just like hair is!

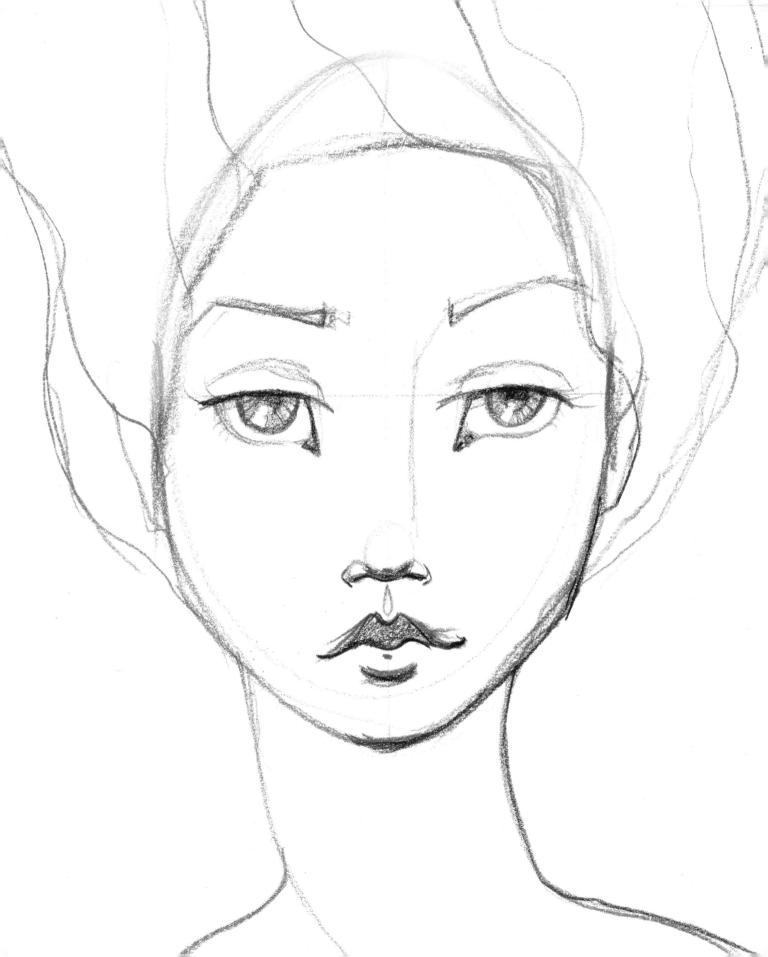

the HOT ZONES

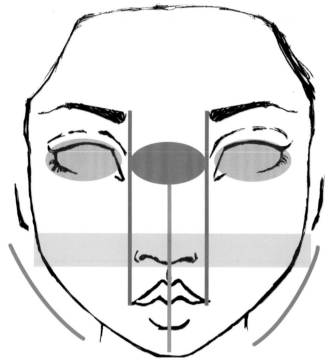

- ● BETWEEN THE EYES
- ● THE STACK
- ● LINE UP
- ● EAR HERE
- ● THE CURVE

Just as in life, chasing balance in your drawings can be an exhausting exercise. Here are some **Hot Zones** to look at when you are creating your faces. If you can get these focal areas singing in harmony, your drawing should look balanced and proportionally pleasing.

BETWEEN THE EYES: Aim for an eye's width between them. In cartoons, a tense, angry or nervous character is usually drawn with close-set eyes; a tired, stupid, or intoxicated person is drawn with very wide-set eyes.

THE STACK: The nose, mouth, and chin should line up, one over the other like a stack of building blocks. If these are out of alignment, the face can look very unbalanced.

LINE UP: The outer corner of the top lip usually lines up with the inner corner of the eyebrows.

EAR HERE: The ears are much bigger than we think. In a realistically proportioned face, the bottom of the ears and nose line up. In a **Jane-Style** face on the next pages, the nose is dropped. Just watch that the ears don't drop as well and get even bigger.

THE CURVE: You can have a lot of fun playing with different face shapes, just try and keep the spot where the cheek turns to the chin even on both sides of the face.

FINDING SYMMETRY

I created this interesting exercise in symmetry for my online class called JOYnal.

1 I started a drawing with the aim of making it as symmetrical as possible.

2 In an editing program (Adobe Photoshop), I copied the right half of the face and flipped it to create a new face.

3 I repeated this with the left half of the face.

You can clearly see how uneven the original is.

HOWEVER! I prefer the first face with all its faults. I think this is because in reality our own faces are not even, so when a face is drawn too perfectly, it looks rather unnatural.

I have found if I look to the **Hot Zones** on the opposite page and get them balanced, I can relax with everything else.

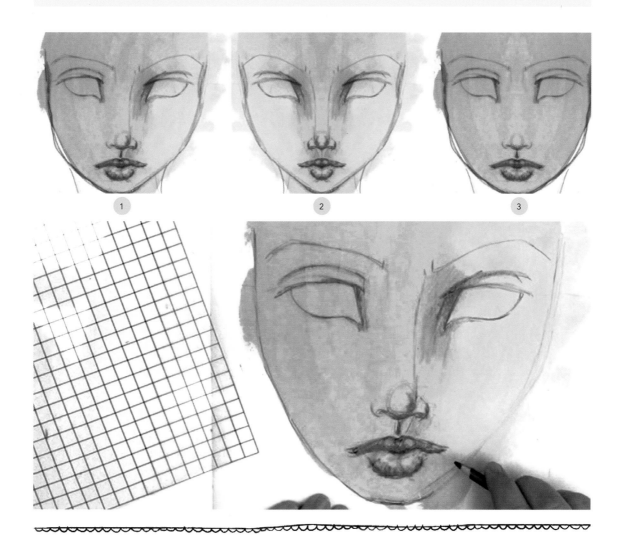

1 2 3

jane-style
WHIMSICAL PROPORTIONS

In reality, all of our features are approximately the same size. But drawing is all about DRAMA for me. As artists, we can play with proportions and look for what we find interesting and aesthetically pleasing.

In my workshops, we refer to **Jane-Style** faces because the proportions I use are so much a part of my art style. I like to give my drawings a look of fragility and a touch of innocence. So I drop the mouth and nose placement to emulate the lack of chin that babies have. To me, it just looks "right." With practice, you will eventually settle upon your own style of proportions that really please you to draw and to look at in your own work.

On these pages, you can see how even minor changes in the placement and size of the features creates such a difference. We are still keeping the **Guide Lines** in mind, but by playing with the size and position of each feature, you can get many surprises!

Playing with proportions allows you to create different faces and create your own style.

Photocopy one of your drawings several times (make one copy 10 percent bigger, and another 10 percent smaller) and cut up the features. You can play with the proportions to make the styles on this page and create many of your own too!

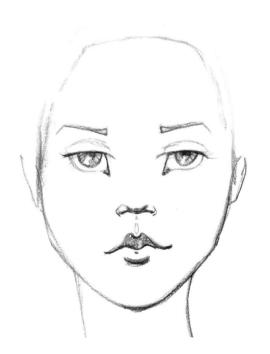

REALISTIC PROPORTIONS

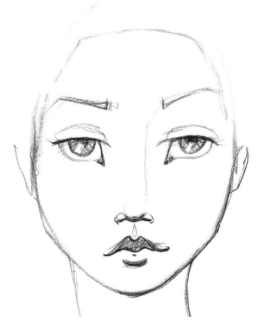

JANE-STYLE PROPORTIONS

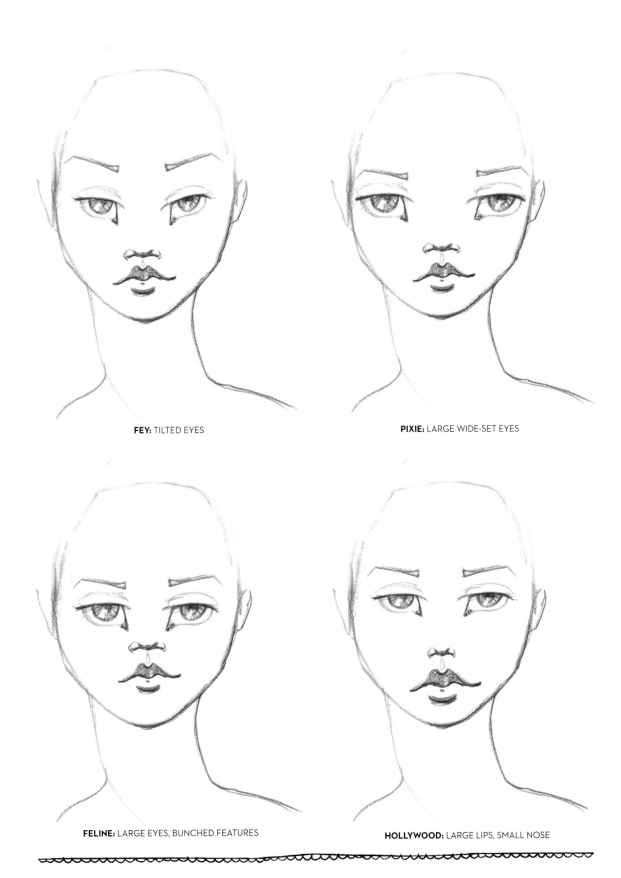

FEY: TILTED EYES

PIXIE: LARGE WIDE-SET EYES

FELINE: LARGE EYES, BUNCHED FEATURES

HOLLYWOOD: LARGE LIPS, SMALL NOSE

SPHERES & LIGHT

Mastering a convincing rendering of geometric shapes has always been a foundational skill for artists. In my workshops, I can almost hear the sigh when I assign drawing spheres as homework because they are not very exciting, right? WRONG! If you can create a lovely 3-D sphere on paper, your face drawing will take on a new life.

Start by lightly drawing a circle. Decide where your lightest and darkest points will be. Start shading with your pencil strokes following the shape of the circle.

It is better to go lightly and build up the darker areas gradually. The more smoothly you go from light to dark, the more volume your sphere will have.

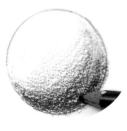

Now you can swap to a darker color, such as indigo, and add your deepest shadows. Keep your pencil strokes following the shape.

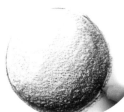

The secret to having your spheres really pop is to add a tiny amount of light between the darkest shadow and the edge. I use a white paint pen or pencil.

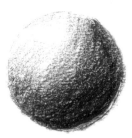

You can think of the whole face as made of spheres. From the "apples" of the cheek, to the chin, eyeballs, tip of the nose, and the nostrils.

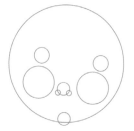

If you can shade these lovely facial contours with drama and confidence, your faces will appear to be coming right out of the paper. This is because we are adding volume.

As an exercise, draw a round **"Draw Happy"** face and then plot all the circular shapes and rounded features on it very lightly. Decide where your light is coming from and make sure all the spheres are shaded with the same light.

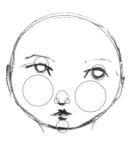

Now turn up the volume by really overdoing the shading! The more dramatically over-the-top it is, the better. I want you to see how much volume you can add by seeing the spheres on the face.

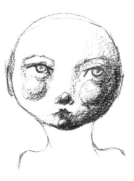

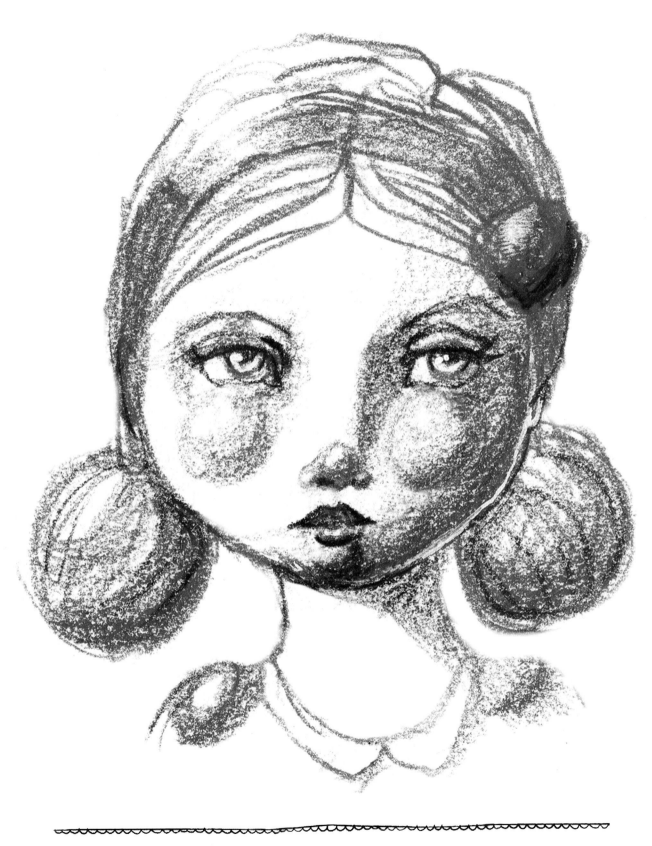

LATITUDE & LONGITUDE

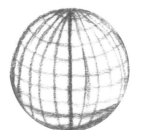

I like to think of the head as a globe. Globes have all those wonderful **Latitude and Longitude Lines;** you can utilize them to help you navigate turned faces.

Try sketching a few globes and, using my examples, try shifting the axis point.

Isn't it fascinating that drawing a series of arching lines can make a simple circle turn into a 3-D form?

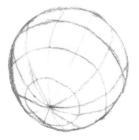

It's not hard to imagine these curved lines forming your **Guide Lines** to help you position the facial features. Of course, the human head is not perfectly round and smooth, but the principle of using the curved lines can be very helpful.

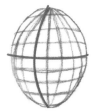 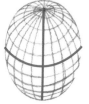 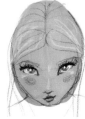

Start with a simple egg-shaped oval. Imagine the **Latitude and Longitude Lines** to help you place your curved **Guide Lines.** You can play with setting up the face to look up, down, left, and right.

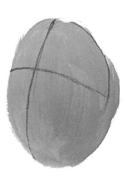

You can start to place your features on the **Guide Lines.** As the face turns, the features themselves change shape and size.

The most dramatic changes are usually the nose and chin because they have so much shape. I will go through those changes in detail in subsequent chapters.

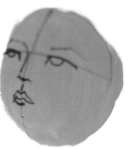

Practice drawing globes and the arched **Latitude and Longitude Lines.** Just like the spheres exercise, it doesn't sound that exciting, but they will keep you from getting lost! This is the start of a long and fascinating journey.

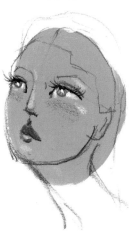

AROUND THE BEND

Practice this principle on some painted ovals.

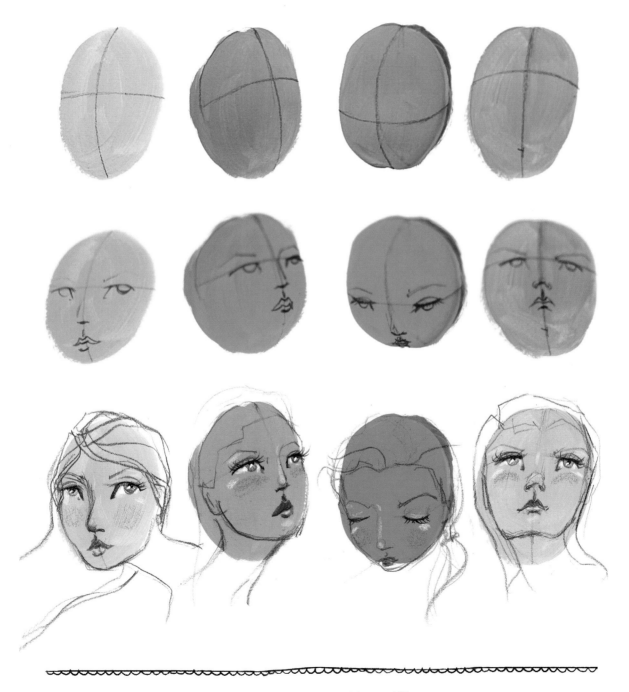

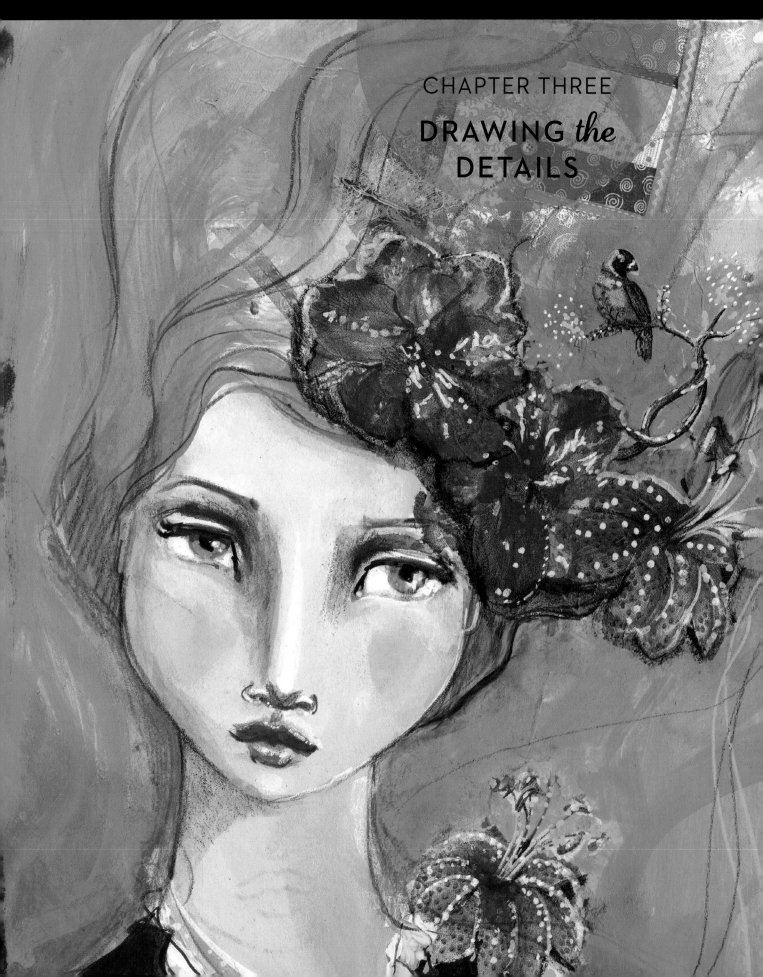

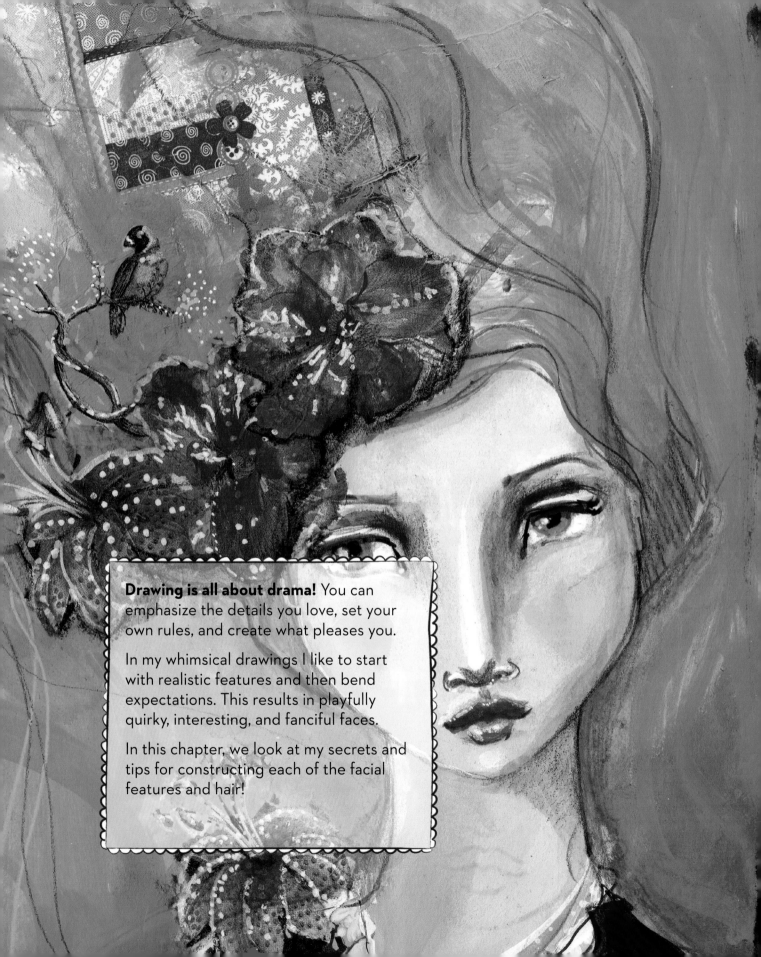

Drawing is all about drama! You can emphasize the details you love, set your own rules, and create what pleases you.

In my whimsical drawings I like to start with realistic features and then bend expectations. This results in playfully quirky, interesting, and fanciful faces.

In this chapter, we look at my secrets and tips for constructing each of the facial features and hair!

LIP *service*

When we start out as children, our lips have the most exquisite shape. As we age, our lips typically get thinner and we must use makeup to bring back that fullness. Some people take it further and use cosmetic procedures to emulate that lost youth. In art, we don't need to go through painful surgery and injections, we can simply draw whatever elements we find most beautiful!

Here are secrets to luscious lips:

Get dramatic. Let your lip lines sweep and curve! I start from the center of the mouth and draw out to each corner.

Lip liner. A heavy outline immediately flattens the volume in a lip and can be a real task to soften. Instead, start lightly and build up color.

Lip color. Be mindful of the colors you use on a child's youthful and innocent face. Deep reds are only achieved with lipstick.

Pillow lips. Think of the lips as having puffy little pillows inside them. As you are shading, curve your lines around these pillows to build in volume.

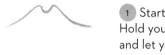

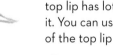

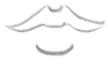

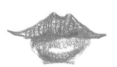

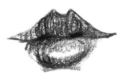

1 Start with the top lip. Hold your pencil loosely and let your wrist do the work.

2 The underside of the top lip has lots of shape in it. You can use the shape of the top lip to guide you.

3 Define the bottom lip with a simple curve. The lower the curve, the fuller that bottom lip looks. The more arched it is, the more pouty it looks. If you flip the arch, the lips will look sulky. Play with that curve!

4 Shade the top lip to add depth because a shadow usually means something is going back and into the paper. Our top lip usually slants back as it comes to the center of the mouth.

5 Shade the bottom lip. Use a lighter hand and leave a curved highlight. The darkest points will be where the lips meet.

6 Add your contours to show the fullness of the lips. The more curved your lines, the more luscious and full the lips will look.

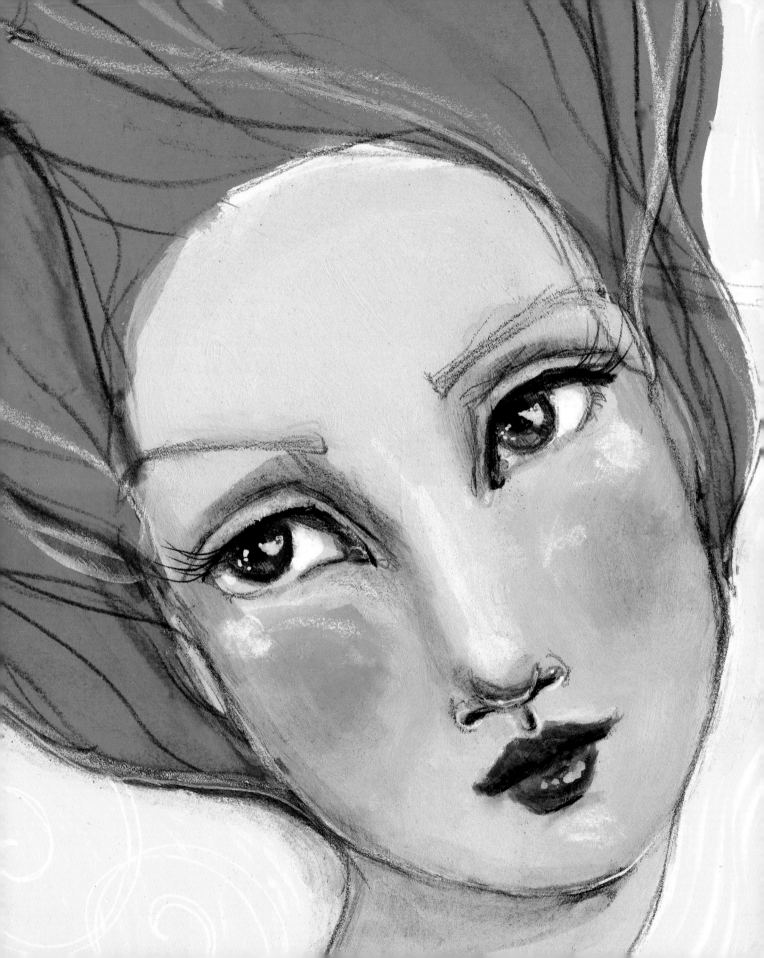

FOLLOW *your* NOSE

Unlike eyes, ears, and lips, there are few defining edges to draw with noses, so we draw the shadows the nose casts to define it instead.

With a face looking straight ahead, drawing the nose is a fairly easy task.

1 Start the nose with three circles. Think of three balls sitting on a table. The larger "ball of the nose" is flanked by two smaller circles that contain nostrils on either side.

2 You can erase the top two-thirds of each circle, which gives you the shape under the nose formed by the nostrils and bridge of the nose.

3 A little bit of shading gives some depth. You can make a darker shade to mark the nostrils.

4 Draw on your sphere-shading skills. Picture which side of the face has more light on it and then shade the ball of the nose. Under the nose sits the philtrum or "lip dip," and you can add some shading there, too.

To make the nose a little more complex, you can add some details to the nostrils.

1 From the front, the nostrils look like squashed tears.

2 Draw the fleshy part of the nostril like two brackets on either side.

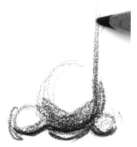

3 Indicate the bridge of the nose by drawing in the shadow it casts. It's better to start lightly and build up to deeper shadows gradually.

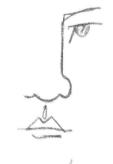

If you add a heavy line, it immediately flattens the face and makes it more stylized and cartoony.

Because the nose juts out from the face, it changes shape rather dramatically as the face turns. But if you keep in mind the spheres that make up the nose, you can use your shading to give lots of lovely volume in your drawings. I will show you more about turned noses in chapter four.

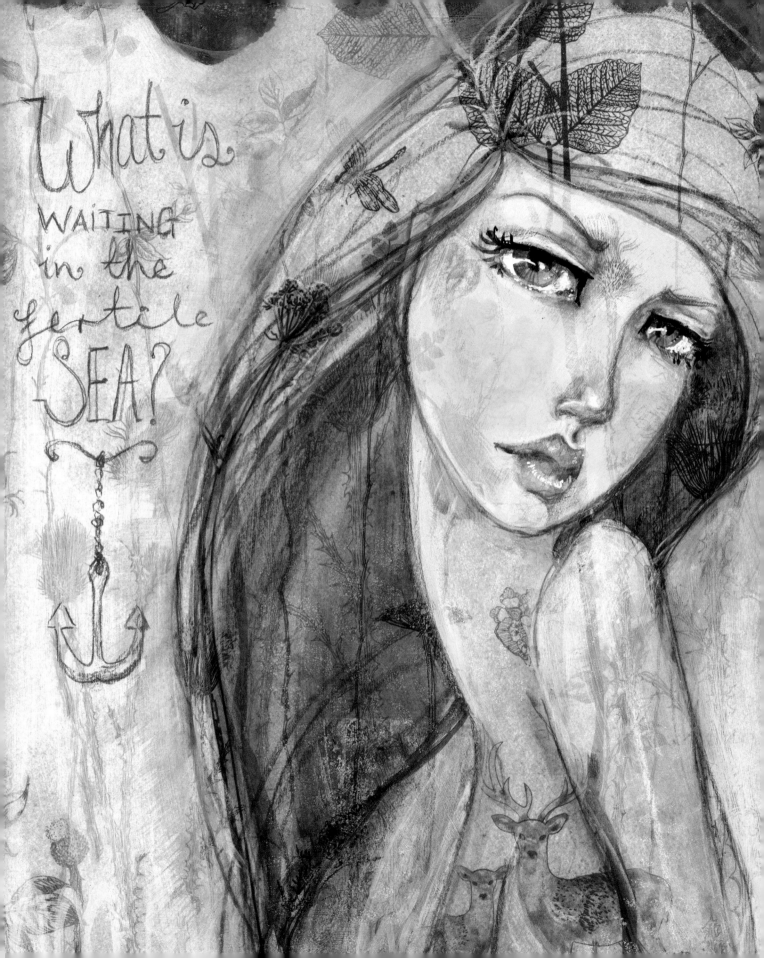

What is
WAITING
in the
fertile
SEA?

the EARS HAVE IT

Ears are such strange things to draw. They are full of odd shapes that are hard to remember without a reference. Even with a photographic reference they are tricky! But without them, the face looks unbalanced and alien-esque.

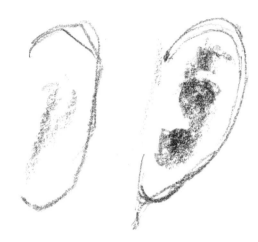

For smaller drawings, I think the key to ears is to keep them simple. On the front-facing head, two little arcs from the eyes to the tip of the nose are sufficient and the less detail the better.

As the head turns, more ear is revealed, but if the other features are kept simple, then just drawing the outer curve of the ear is all you need.

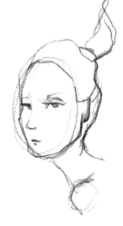

If you want to draw a larger head, then a more detailed ear will look great.

I try to match the same level of detail on all the features so the drawing looks balanced. Of course this is not a rule, it is only a preference according to my own sense of aesthetics.

Using these examples and photographic references, come up with a library of ears in varying degrees of complexity so you can construct ears without fear.

If you draw more complex features, you will need to add more detail to the ear so it is in keeping with the more developed drawing.

Don't forget to add hair in front of the ear as well.

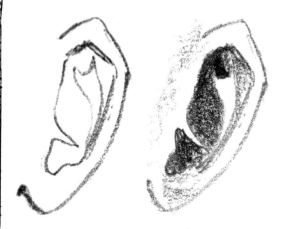

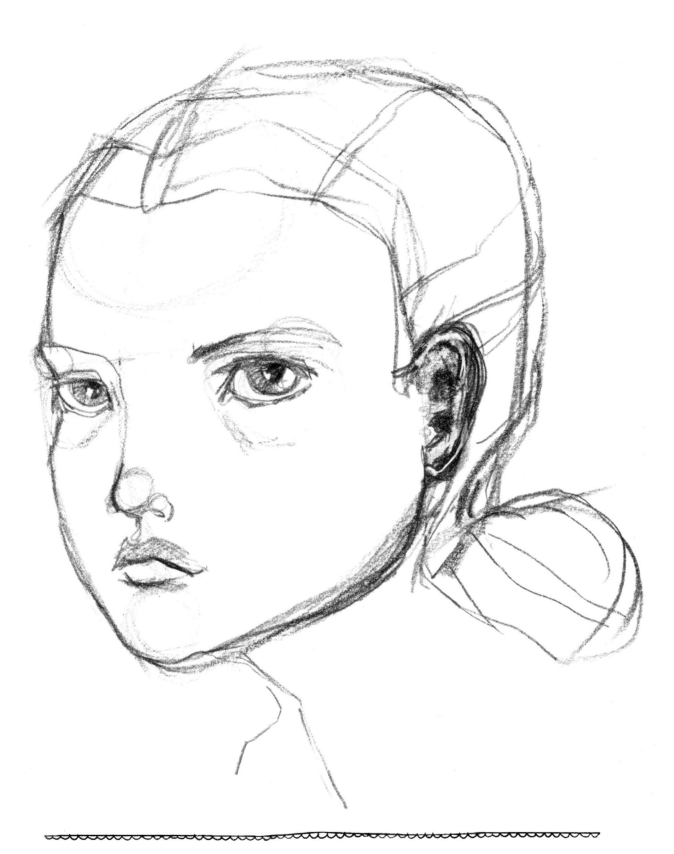

jane's WHIMSICAL EYES

Eyes steal all focus in an image because they are so important for us to read body language.

They also stand out because they are glossy, high contrast, smooth, and colorful.

When I am creating, I often leave eyes until last as a little treat because they are so much fun to draw and paint.

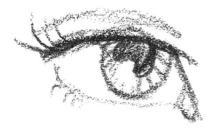

Here are a few secrets for drawing eyes:

Build both eyes at the same time. You can so easily paint yourself into a corner by creating one perfect eye and never get the other to quite match up.

Lashes are curved. Just about all the lines in the eye are curved, especially the lashes. Make them as dramatic or subtle as you like, so long as they are curved.

Upper eyelids have shadow. There is a shadow cast onto the eyeball from the upper lid. Adding it in will give your eyes beautiful depth.

Don't forget the tear ducts. That essential corner detail adds drama.

Add variety. The eyelid crease can have a dramatic effect on eyes. The further away the creases are from the lash line, the more hooded the eyes will look. The darker they are, the more deep set the eyes.

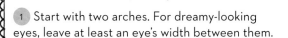

1. Start with two arches. For dreamy-looking eyes, leave at least an eye's width between them.

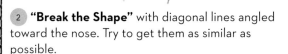

2. **"Break the Shape"** with diagonal lines angled toward the nose. Try to get them as similar as possible.

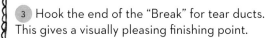

3. Hook the end of the "Break" for tear ducts. This gives a visually pleasing finishing point.

4. Add a circle for the iris. For whimsical and relaxed eyes, tuck them under the upper lash line.

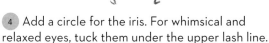

5. In reality, pupils are dead center in the iris, but you can lift them a little so the eyes don't look startled.

6. Color the iris with lines radiating out from the center like the spokes on a bike wheel. Leave a highlight.

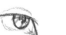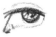

7. Define the lower eyelid. Add some curved lashes and a few subtle lower lashes. The shape of the upper eye crease adds a lot to the expression, so play with that!

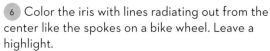
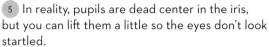
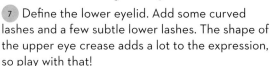

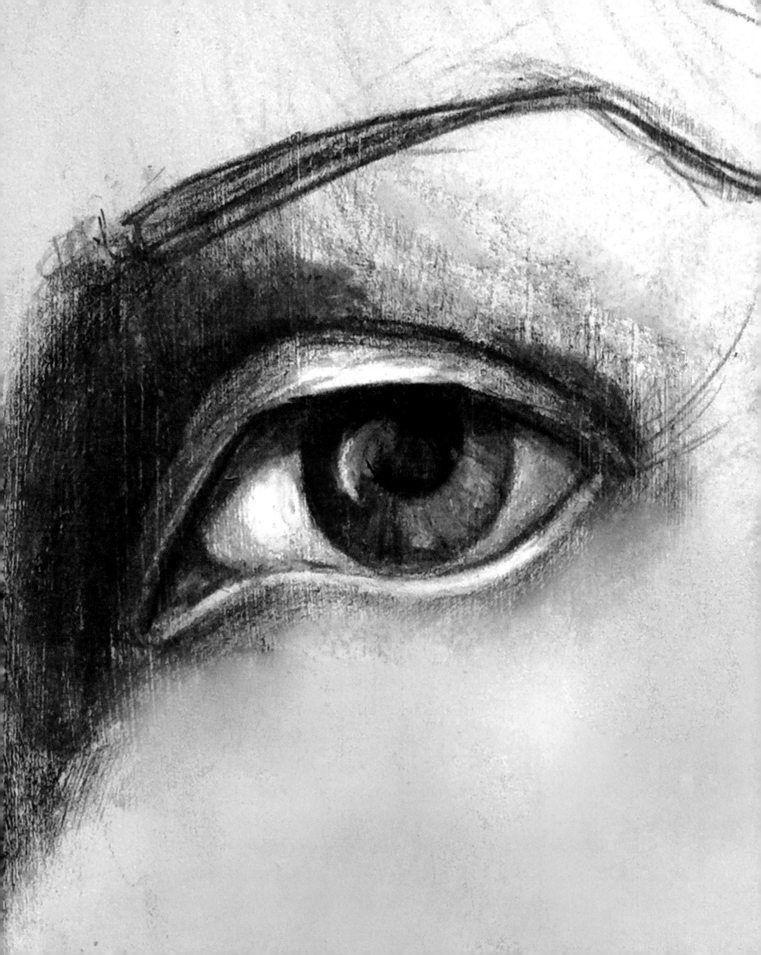

BROWS & LASHES

HAIR

EYELASHES

Eyelashes have a lovely curve to them.

1 Flick your wrist as you draw lashes to get that curve.

2 Eyelashes clump together to form a dramatic frame around the eye. The lower lashes are hardly visible unless you are very close, but you can hint at them.

Here are a few of my do-not-draws:

- Straight lashes
- Lashes all around the eye
- Parallel lines
- Single lashes

EYEBROWS

1 Start at the center of the face and draw a slanted check mark.

2 Add a top line to complete the shape.

3 Complete the eyebrow with a pointed tail.

4 Add a few hairs leaning at the same angle as the brow shape.

These are things to avoid:

- "Rainbrows" are perfect rainbow-shaped arches.
- Eyebrows can dominate the drawing if they are very dark and heavy.

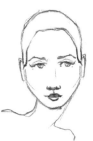

Hair is wonderful to draw and over the following pages we will look at various hairstyles. But first, let's go over some of the basics.

There is quite a bit of shape to the hairline. The most important thing to remember is that hair comes in front of the ear as well as behind it.

Hair is a wonderful opportunity to add movement to a drawing. Think of moving hair as clustering together and forming sections. Rather than draw individual hairs, we will draw the sections and keep them all flowing in the same general direction.

PART LINES

Here's a little hint for getting your lines flowing around the head:

1 Draw in the part.

2 Add little curved lines coming from the part, like asymmetrical letter Ys.

3 The **Part Lines** give you a start to drawing the rest of the hair.

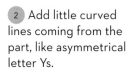

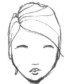

FRINGE & PARTS

FRINGE ON

The trick with hair is to let your lines be free. If you add in movement to your lines, the hair will look like it has movement.

① Start with a curved line across the forehead.

② The lines you draw from the hairline to the "hem" of the fringe need to be curved. Think back to the **Latitude and Longitude Lines.** The more bend you get into the lines, the fuller the fringe will look.

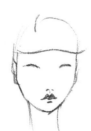

③ If you thicken up the hem line, the fringe will look denser. If you erase that hem line and allow more skin to show, the fringe will look wispy.

If you want the fringe to look very blunt, keep the hem line straighter (but not dead straight).

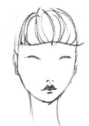

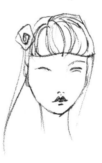

SWEEP IT BACK

① When drawing a part in the hair, start with a simple curved line where you want the part. The line will be more curved if the head is turned. For this example, it looks fairly straight, but a slight bend will look more natural.

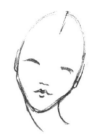

② Sweep the hair from the part to the ears with a continuous flowing line.

③ Add little asymmetrical Y shapes curving out of the part.

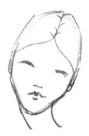

④ Use the **Part Lines** to start a curve that follows the shape of the head in the direction you want the hair to flow.

⑤ Hair doesn't like to be constrained, so let a few strands fly away.

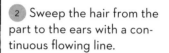

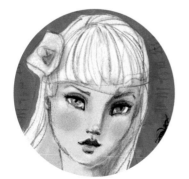

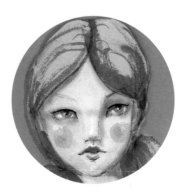

CURLS & UPDOS

TUMBLING LOCKS

Curls defy gravity and are a wonderful way to express the lightness of being.

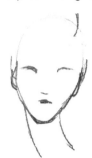

1 Decide on the part and place a curved line from the hairline to the top of the head.

2 Add your **Part Lines.**

3 Draw a lively line from the part to just in front of the ear. Let the pencil misbehave. The less controlled and contrived your lines, the better.

4 Define the end of the hair with another free line. I curve my line to give the hair "lift."

5 From your **Part Lines,** add your curls. They do not need to go all the way to the ends.

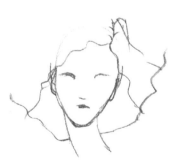

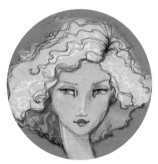

ALL DRESSED UP

Drawing dramatic hair buns is a joy! There is something naturally whimsical about them!

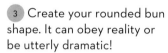

1 Decide on your part and sweep the hair to the ears.

2 Add your **Part Lines.**

3 Create your rounded bun shape. It can obey reality or be utterly dramatic!

4 Draw flowing hair from the part to the side of the head.

5 For the bun, get your hair lines as arched as possible to add contour and shape.

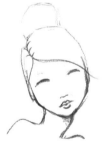
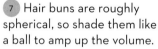

6 Play up the darker and lighter areas to add volume!

7 Hair buns are roughly spherical, so shade them like a ball to amp up the volume.

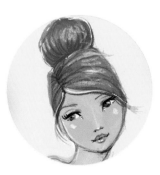

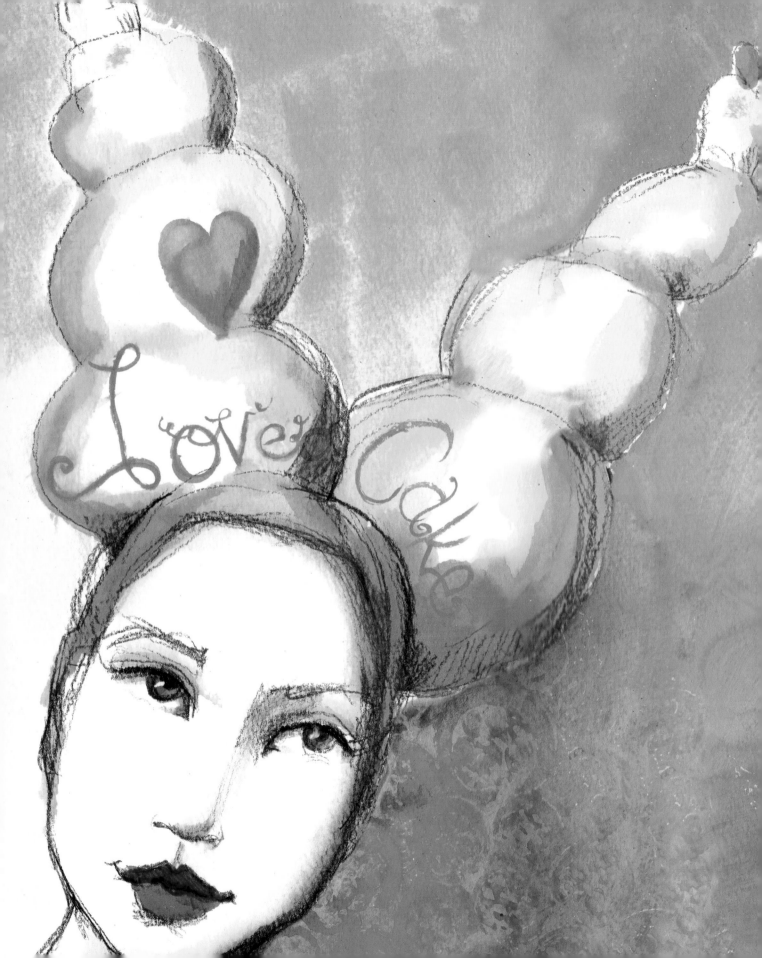

WET & WINDY

DRIPPING WET

Imagine a mermaid emerging from the salty depths or a girl caught in the rain . . .

1. Start with the part and add your **Part Lines.**

2. Sweep a line from the part to the ears.

3. Draw in the outer shape of the hair close to the scalp. When the hair is wet it sticks to the head and reveals the angles of the skull.

4. To make the hair look very wet, let some strands hang down across the face.

5. Hair usually looks much darker when it's wet and loses its volume.

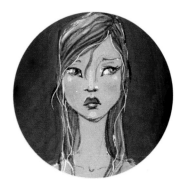

GONE WITH THE WIND

The best part about drawing from your imagination is you don't have to obey any rules. We can ignore gravity!

1. Define the hairline.

2. Decide which direction you want the hair to be blowing in.

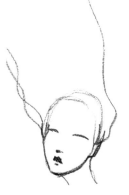

3. Create body and volume by drawing loose and lively lines beginning in front of the ears and then up, up, and away!

4. Add more hair with swooping nonparallel lines.

5. Clump several lines together to give the hair body.

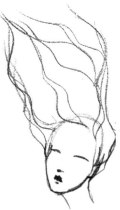

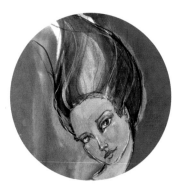

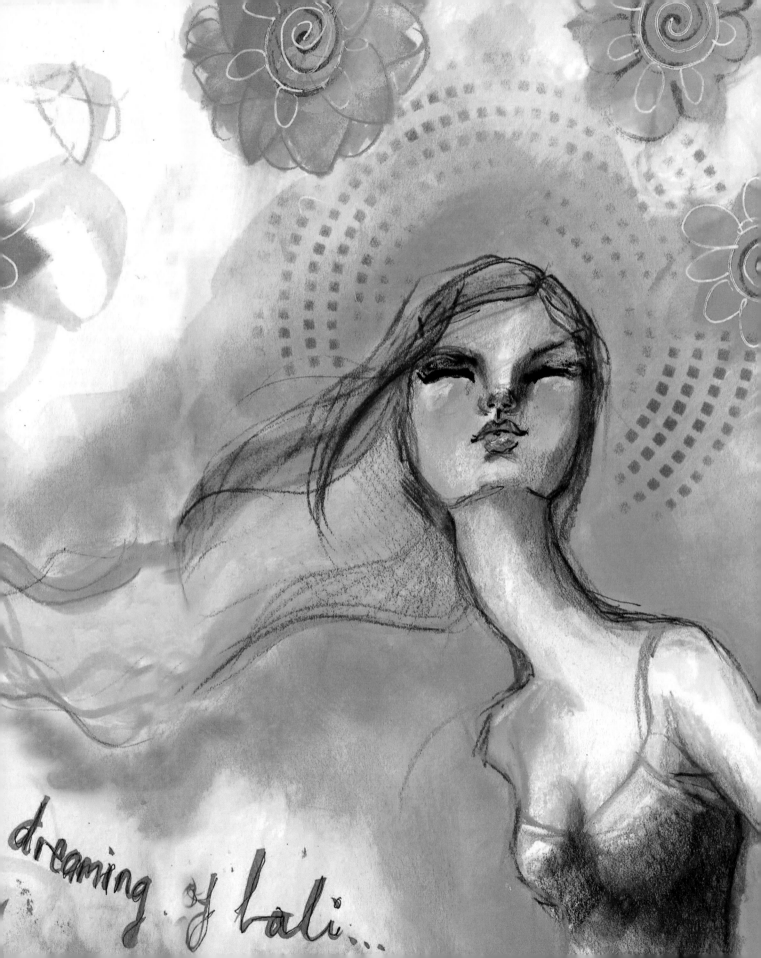

dreaming. of Lali...

TWISTED & BRAIDED

BRAIDS

Braids have an innocent, storybook quality to them.

① Start by plotting where you want the braid to fall.

② On one side, add a series of arches. The more curved they are, the thicker and fuller the braid will look.

③ On the opposite side of the braid, make the same arches, but place them asymmetrically.

④ Here comes the tricky bit! You want to draw a partial diagonal line from the bottom of one arch to the bottom of the arch on the other side.

⑤ Repeat the process from the other side.

⑥ You can add some lines to show how the hair gathers into the braid.

Practice a few times and you will get it!

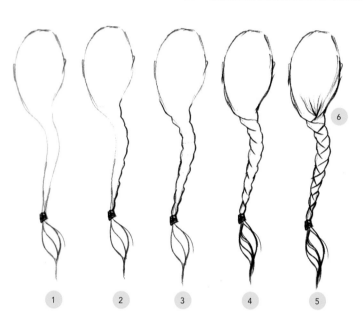

TWISTS

You can also simply draw the hair in a romantic and slightly impossible twist. The process is similar to braids, but you just use one diagonal line.

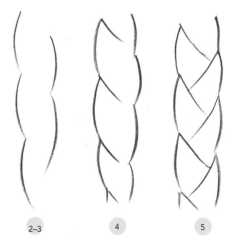

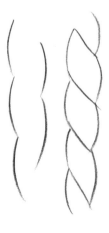

Note: Drawing a Unicorn's horn is done the same way—just in case you were wondering!

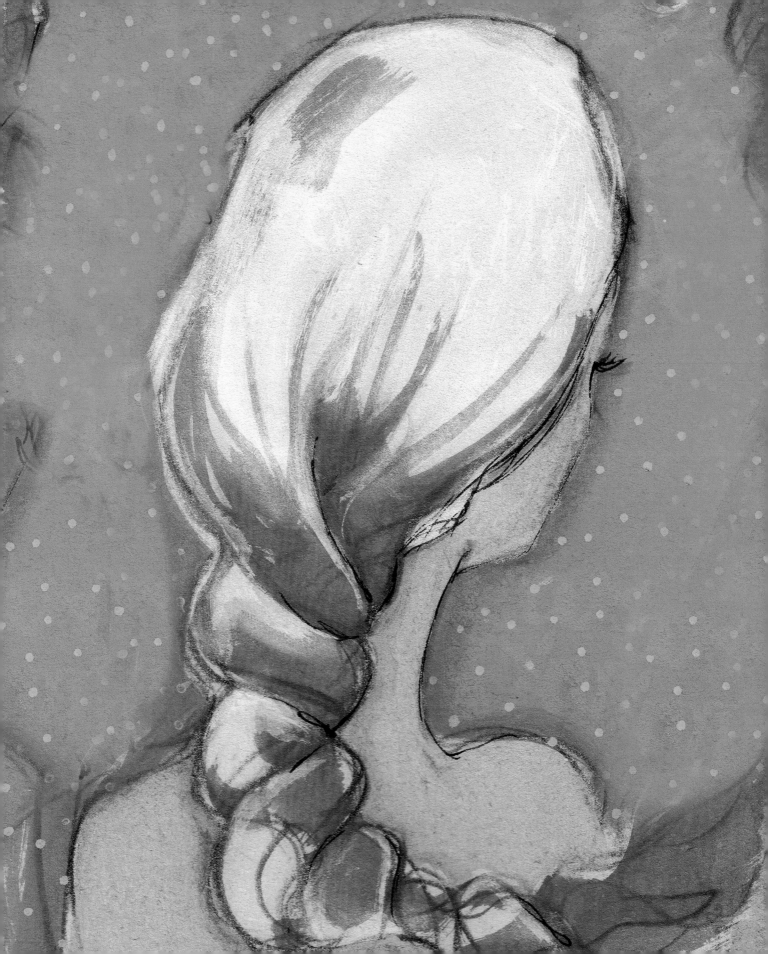

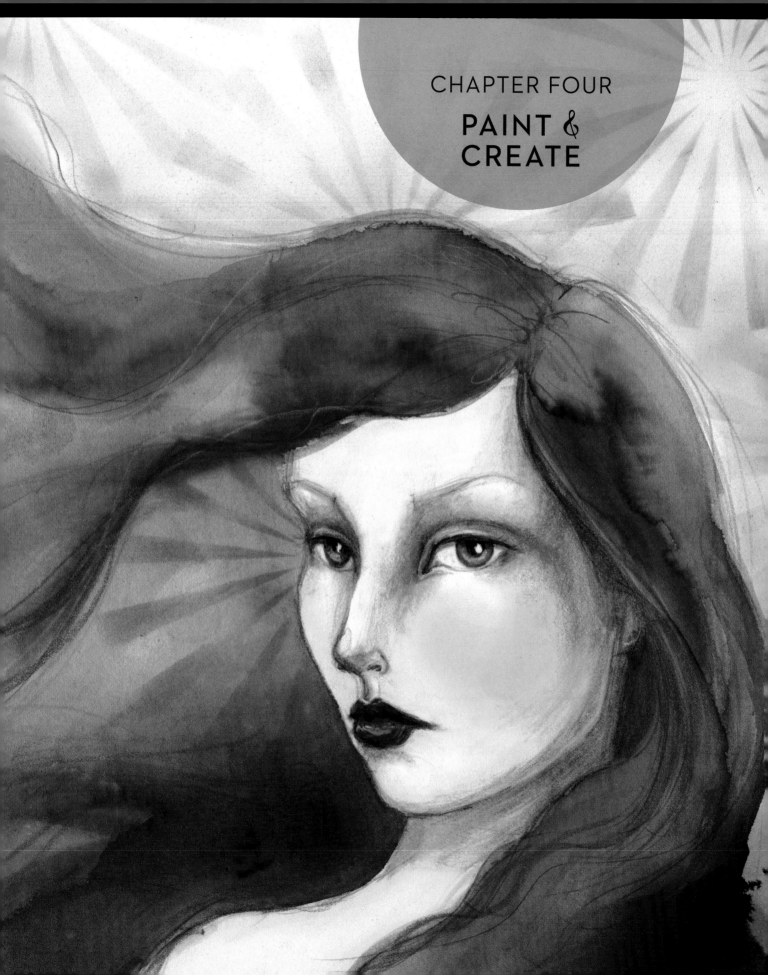

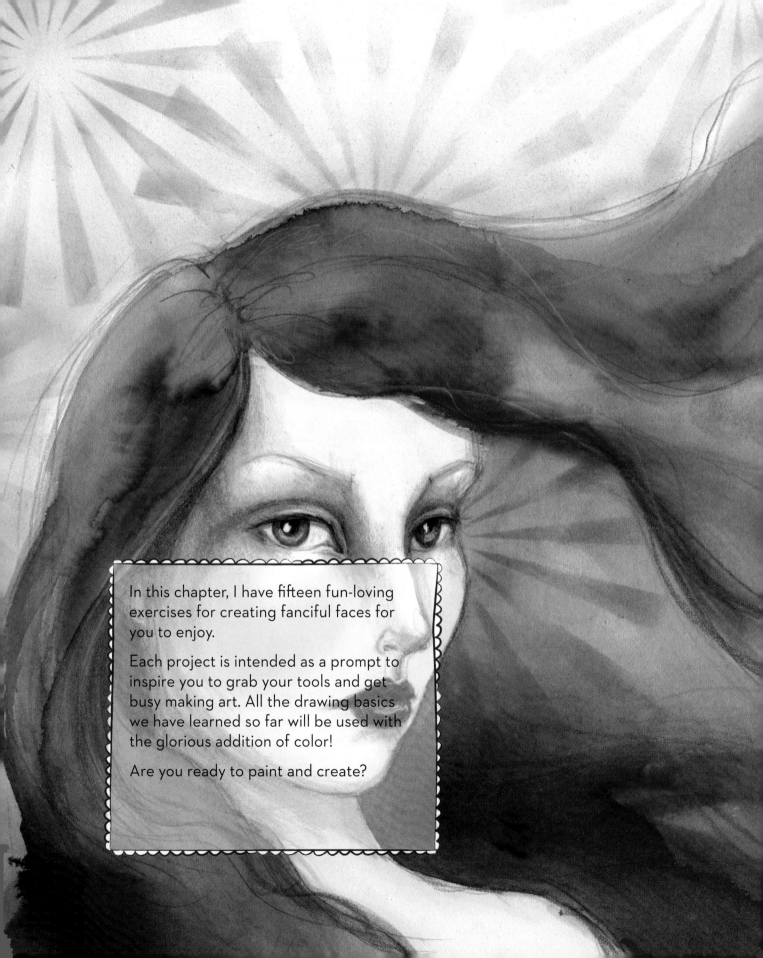

In this chapter, I have fifteen fun-loving exercises for creating fanciful faces for you to enjoy.

Each project is intended as a prompt to inspire you to grab your tools and get busy making art. All the drawing basics we have learned so far will be used with the glorious addition of color!

Are you ready to paint and create?

jane's WHIMSICAL TECHNIQUES

In each exercise you are invited to join me backstage and see how the final piece comes together. These are techniques I use on a regular basis. You have the best seat in the house, perched on my shoulder as I create artwork in my journal!

I use a wide range of materials and will mention brands and color names for your reference, but you can substitute them with whatever you have handy. Having the same supplies I use won't make any difference to your artwork. What will make a difference is doing the exercises and being open to making mistakes.

Always remember your supplies WANT to get messy, broken, and emptied. Unless you are creating an art supply museum, get everything out of the boxes they came in and into the spotlight.

Here is a simple warm up to get us started right away!

Gather your favorite pens. I love using ink in a waterbrush.

Cut an oval face shape from an old book.

Create a **"Draw Happy"** face in ink, on the paper.

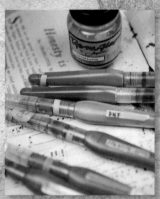

Paint bright, rosy cheeks. Let it splotch and puddle.

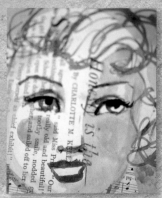

Add a color to one side of the face to add depth.

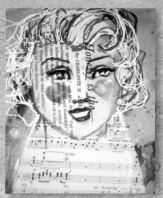

White paint pen can define eyes and details.

INTO *the* SHADOWS

Defining the Highs and Lows of the Face

Shading faces is an area that holds a lot of fear for new artists. I think this is because, in reality, we have many light sources falling on a subject at any one time and every slight movement of the head changes the shadows and highlights.

When drawing faces from the imagination, we can set our minds free of that complexity, and instead, envisage one source of light falling on our subject. I like to think of a slightly over-cast, yet sunny day where there is plenty of golden light. The shadows are not too harsh and they all fall in the one direction. This simplifies the shading no end.

Now, think of the face as a landscape of hills and valleys. To make the valleys sink back into the paper and away from us as the viewer, we make them darker. To bring the hills out of the paper and toward us as the viewer, we make them lighter.

This straight-forward method of shading gives plenty of volume and will help you let go of any fears of getting it wrong because you can always feel your own face as you draw. If something protrudes, make it lighter. If something sinks in, make it darker. It's simple.

TURN ON THE LIGHT

It's just a matter of using darks, lights, and mid-tones to create volume.

Before we start, let's define the light source and where it's coming from. Imagine the sun perched in the sky at about 3 p.m.—not straight above, but sending light at an angle. Shadows are not too harsh, and they all fall in the one direction.

The light falls across your face on a diagonal, sending the deeper parts (the valleys) of the face into shadow and allowing the protruding parts (the hills) to catch the sun.

In this exercise, I use PanPastels because they are easy to blend, but any art material can be substituted.

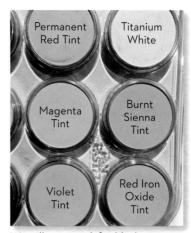

We will use a pink for blush, two lilacs for shadows, white for highlights, and two skin tones.

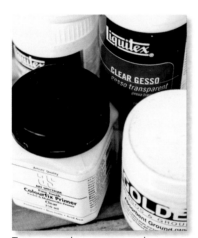

To prepare the paper, use clear gesso, pastel ground, or Colourfix Primer. Let it dry overnight.

Start with a sketch in a skin-tone pastel pencil.

Load your darker skin tone (Red Iron Oxide Tint).

Place the darker skin tone into the deep parts of the face. Use the **Shading Map** as a guide.

The drawing is already starting to look dimensional.

Place the lighter skin tone around the eyes and at the edges of the face and hairline (Burnt Sienna Tint).

A TOUCH OF COLOR

Adding color to the face starts with the areas of skin that are very fine, such as around the eyes where veins are closer to the surface.

Cheeks, lips, tear ducts, and the lower eyelid also hold a lot of color that can be dramatized to great effect!

"Blushing" can be added to other areas too, like the end of the nose, décolletage, the chin, and joints.

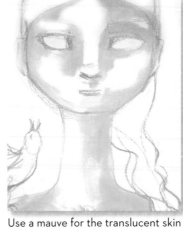

Use a mauve for the translucent skin around the eyes (Magenta Tint).

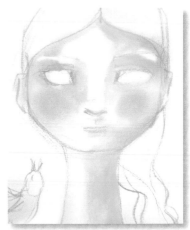

The apple of the cheeks can be swirled in (Permanent Red Tint).

Layer white on the high points of the face (*i.e.*, cheekbones and brow bones).

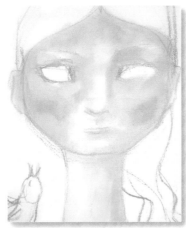

Deepen the eye sockets with the darker purple (Violet Tint).

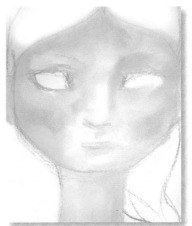

Lightly blend the pastel that has been layered so far.

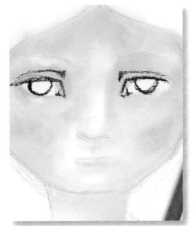

Define the lash line and the eyelid crease with a dark brown pastel pencil.

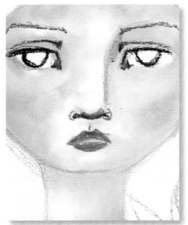

Add a deep coral for lips, tear ducts, and nose details.

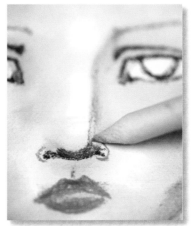

Soften the lines by blending lightly with a paper stump.

HOME STRETCH

Now it's time to start adding the details and let the developing story in the artwork emerge.

You can change the expression just with the tilt of an eyebrow.

Even the hairstyle you choose for the drawing is going to help tell the story.

With a bit of practice, braids are fun to draw. They add a whimsical air of innocence, as well as a strong graphic element.

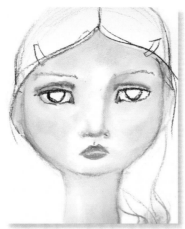

Define the hair and other major details in the drawing.

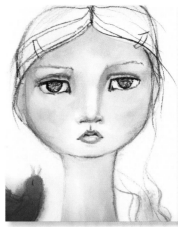

Integrate the eye color with other elements elsewhere in the artwork.

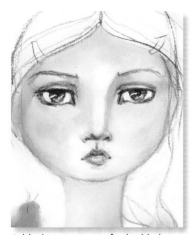

Add white paint pen for highlights in the eyes and black pen for pupils.

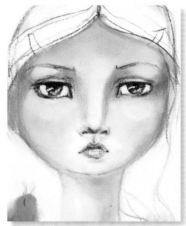

Add light layer of colored pencil in Parma Violet to deepen the temples.

Add your background with acrylic paint.

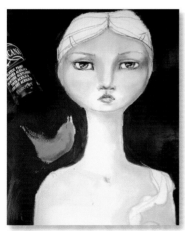

You can use your background paint to refine the drawing edges.

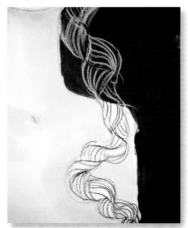

China marker and colored pencil are wonderful for drawing stylized hair.

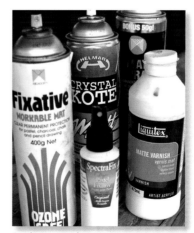

Seal your work. I use a matte spray fixative, let it dry, and then carefully apply Liquitex Matte Varnish.

DARK AND LIGHT

To help you navigate this facial landscape, I created two maps on tracing paper for you.

The deepest areas of the face are marked out on the **Shading Map** in purple.

The highest points of the face are marked on the **Highlight Map** in white.

I suggest you create some shading maps of your own from your work to help you define and memorize the terrain.

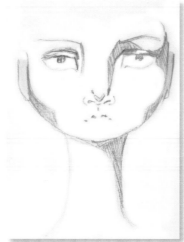

Shading Map: These are the locations of the deepest parts of the face for darker shading.

Highlight Map: These are the locations of the highest parts of the face for lightest shading.

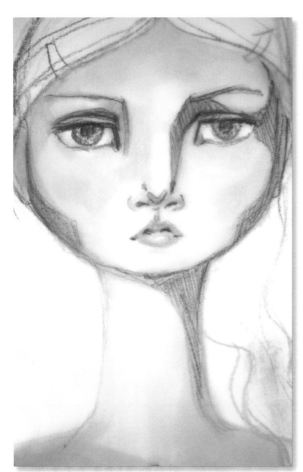

Shading Map as an overlay on the artwork for the following exercise.

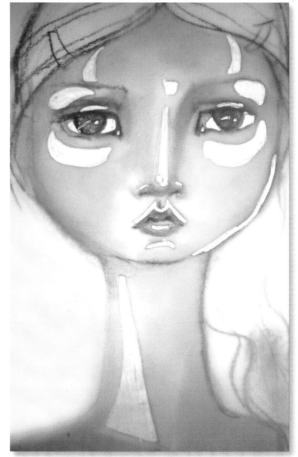

Highlight Map as an overlay on the artwork for the following exercise.

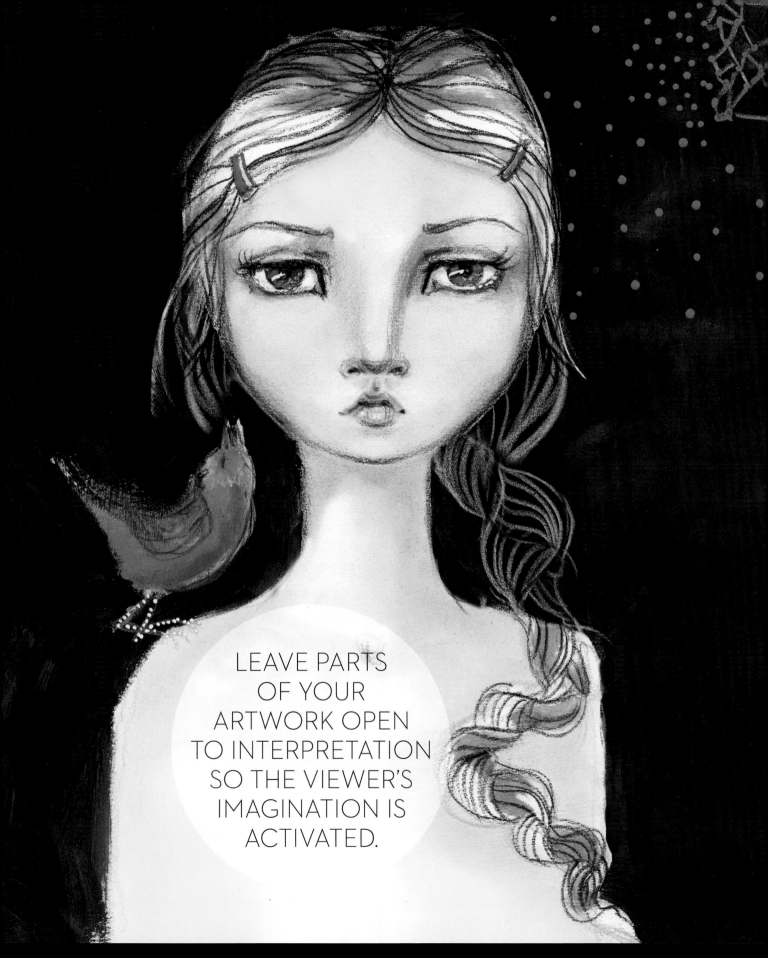

LEAVE PARTS
OF YOUR
ARTWORK OPEN
TO INTERPRETATION
SO THE VIEWER'S
IMAGINATION IS
ACTIVATED.

LAYER *love*

Mixed media is a free pass to awesomeville! Gone are the days of sticking to one medium.

Let's mix it up with water-color, acrylics, and ink. But first, we start with a colored pencil sketch

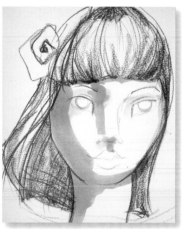

Add a wash of light brown water-color in the deepest parts of the face.

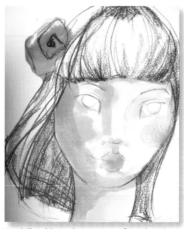

Puddle diluted magenta for cheeks, lips, and flowers!

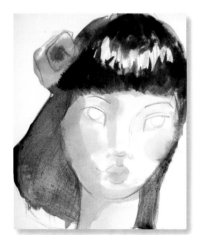

Hair color is made more dramatic by leaving the white highlight.

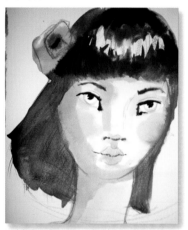

Add the deepest shadows. I use Payne's gray.

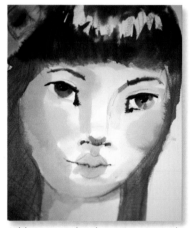

Add an eye color that contrasts with the hair. I used Dye-Na-Flow ink.

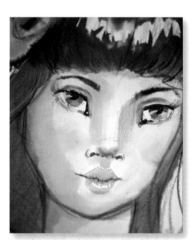

Let the ink and watercolor dry before adding detail with colored pencil.

Build a second subject in the same way.

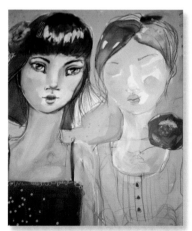

For areas that need opaque cover-age, use acrylic paint.

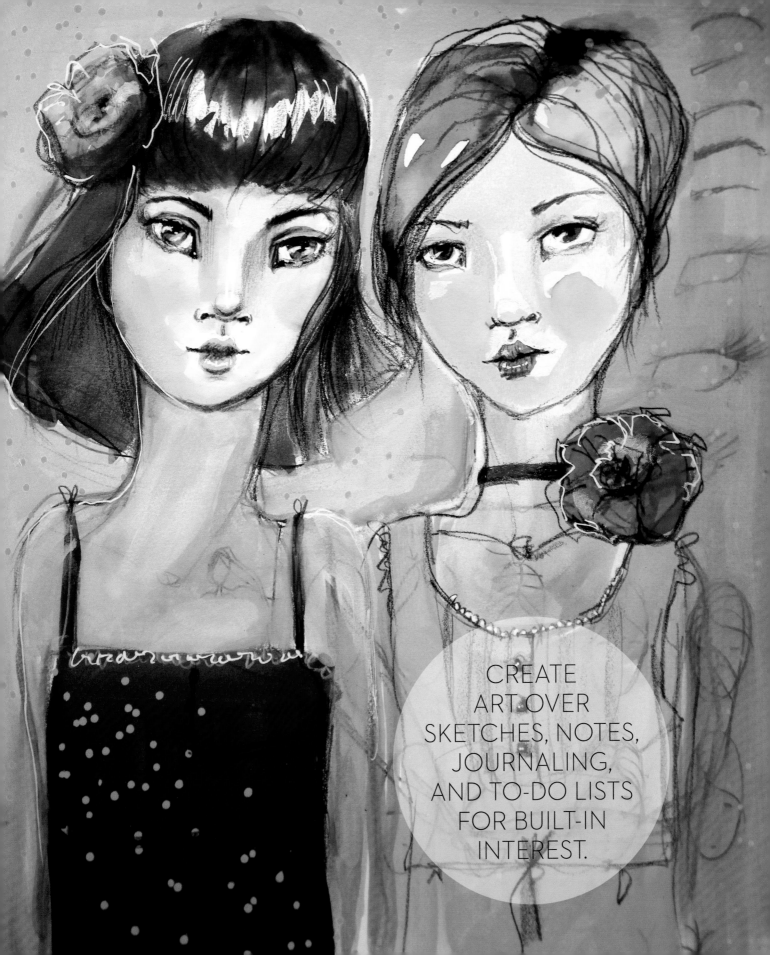

CREATE ART OVER SKETCHES, NOTES, JOURNALING, AND TO-DO LISTS FOR BUILT-IN INTEREST.

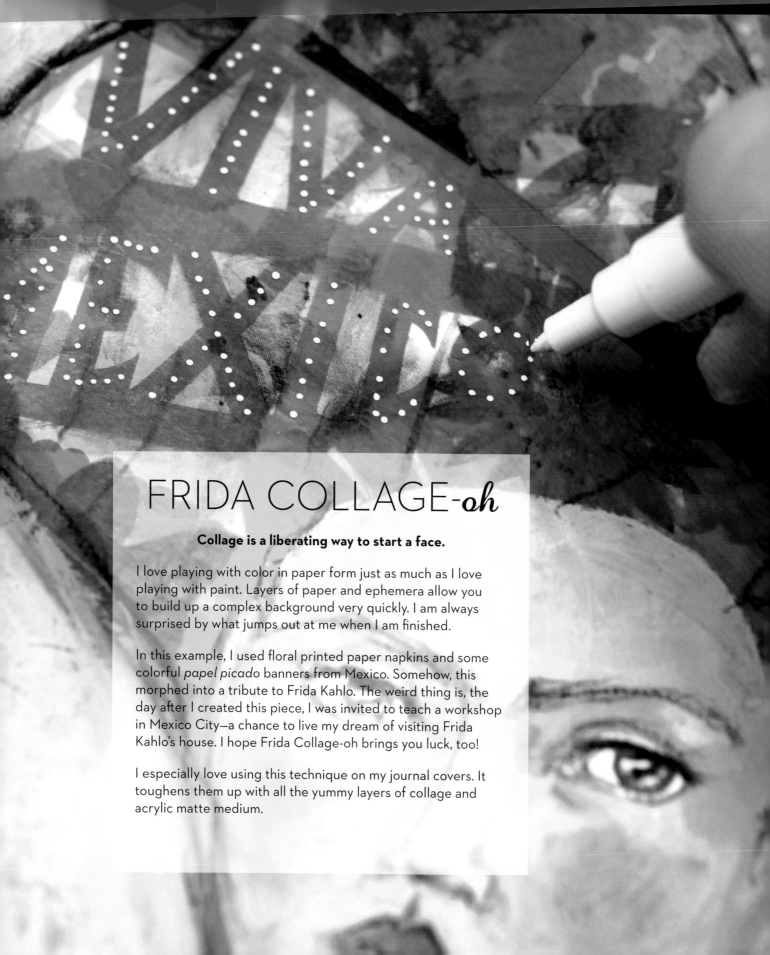

FRIDA COLLAGE-*oh*

Collage is a liberating way to start a face.

I love playing with color in paper form just as much as I love playing with paint. Layers of paper and ephemera allow you to build up a complex background very quickly. I am always surprised by what jumps out at me when I am finished.

In this example, I used floral printed paper napkins and some colorful *papel picado* banners from Mexico. Somehow, this morphed into a tribute to Frida Kahlo. The weird thing is, the day after I created this piece, I was invited to teach a workshop in Mexico City—a chance to live my dream of visiting Frida Kahlo's house. I hope Frida Collage-oh brings you luck, too!

I especially love using this technique on my journal covers. It toughens them up with all the yummy layers of collage and acrylic matte medium.

Gather your ephemera. Work intuitively and let the colors guide your selection.

Start to layer two or three tissue papers using matte medium as glue.

Add as many layers as you like and then leave the collage to dry.

Draw or stencil a face with ink to get off to a quick start.

Paint right over the guide lines with a skin-toned matte paint.

Leave space for the collage to show through the lips.

Mix paint with a little matte medium to create translucent glazes.

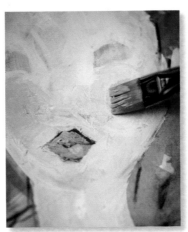

A pink glaze brings a rose to the cheek.

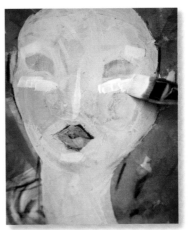

A white gesso glaze makes a nice wash for highlights.

DEFINING CHARACTER

At this point, you can start to define the details of your subject. Sometimes you get a feeling for exactly who it is that you are creating, and sometimes it's a mystery that's never solved.

Once I knew who this person was, I referred to photos of the great lady herself and morphed this with my natural, whimsical style. Combining the real with fantasy is a lot of fun!

Define the subject's edges with a water-soluble All pencil.

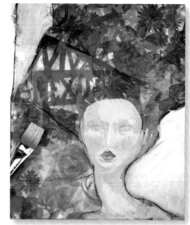

Paint gesso over areas that are not the face or the hair. This will now be the background.

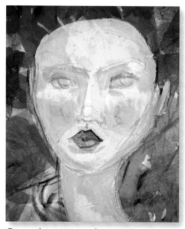

Once the paint is dry, you can redefine your details.

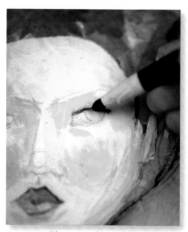

A trusty China marker adds definition to the lashes.

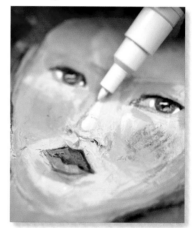

A white paint pen is perfect for adding highlights to the eyes and nose.

Ensure the bottom lip gets a touch of white, too, to make it protrude.

Bring out details in the collage with pens.

Add elements such as a few hair lines.

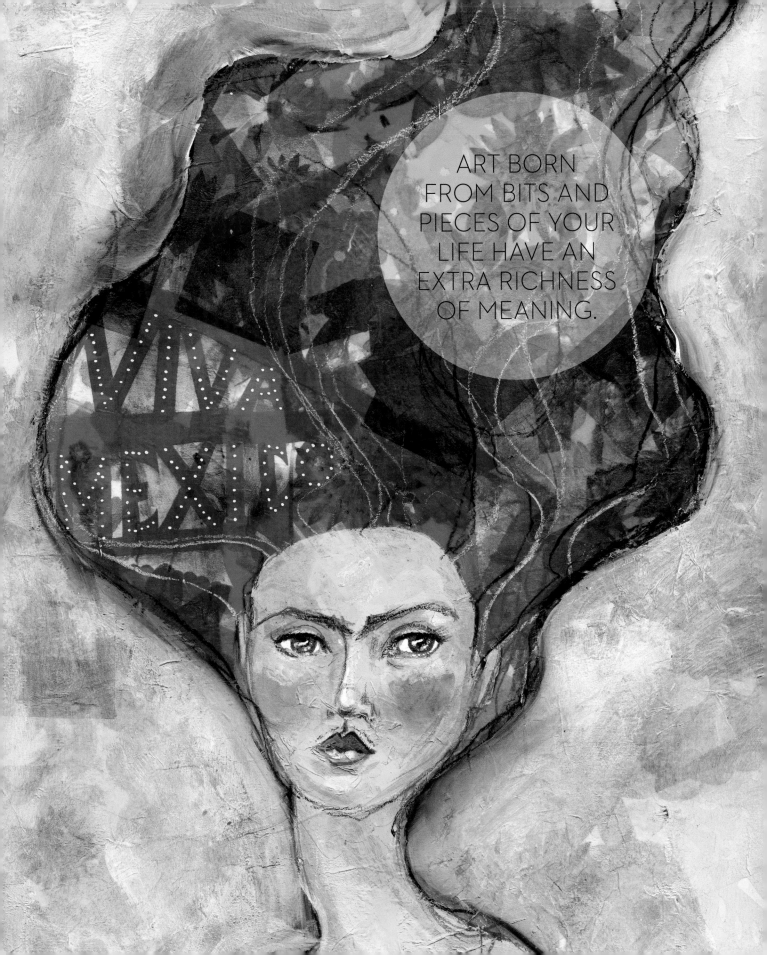

ART BORN
FROM BITS AND
PIECES OF YOUR
LIFE HAVE AN
EXTRA RICHNESS
OF MEANING.

PRINTS *charming*

In this next exercise, we start with a cacophony of color and activity by using ephemera to quickly build a complicated background and let the collage shine out through the face this time.

Collage is fun because it triggers ideas and allows you to close in on them quickly.

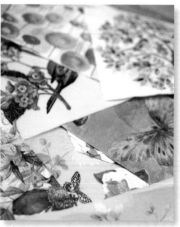

Select some pretty napkins and papers from your stash.

Glue them all down with Liquitex Matte Medium, layer over layer.

Once the matte medium is dry, sketch out a face.

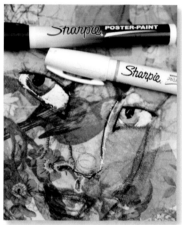

Bringing out the detail on so much busyness needs a bold approach.

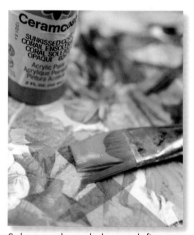

Select a color to help you define your subject.

With the face defined, you can make decisions about the hair shape.

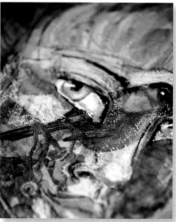

Overemphasize features so they stand out within the collage.

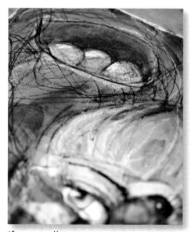

If your collage areas give you exciting ideas, go with them!

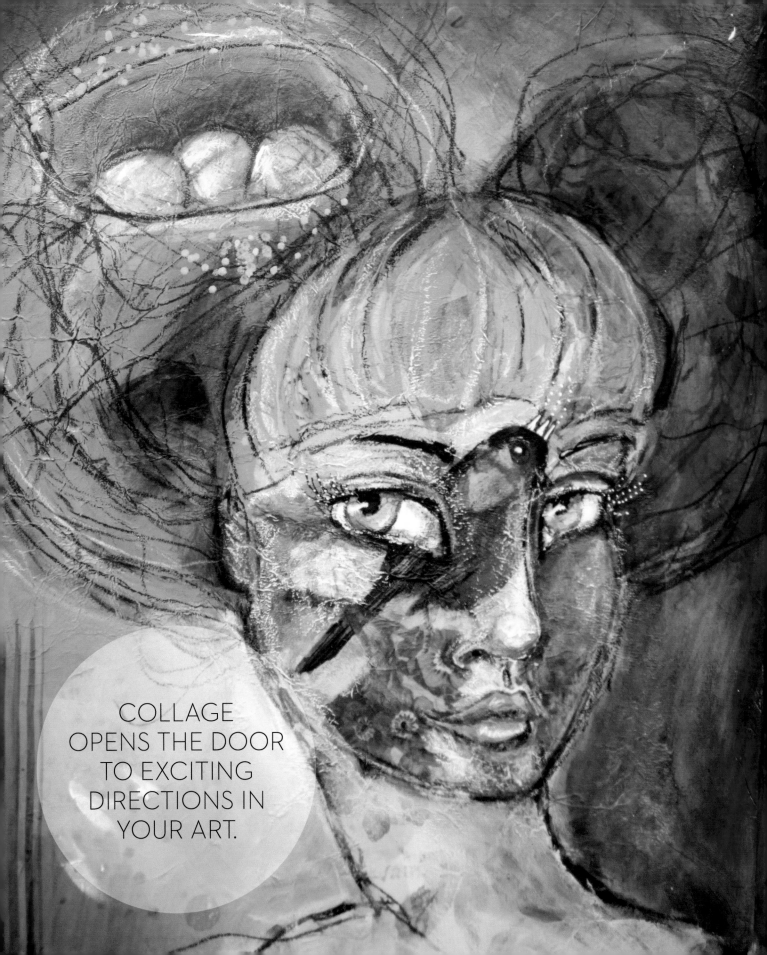

COLLAGE
OPENS THE DOOR
TO EXCITING
DIRECTIONS IN
YOUR ART.

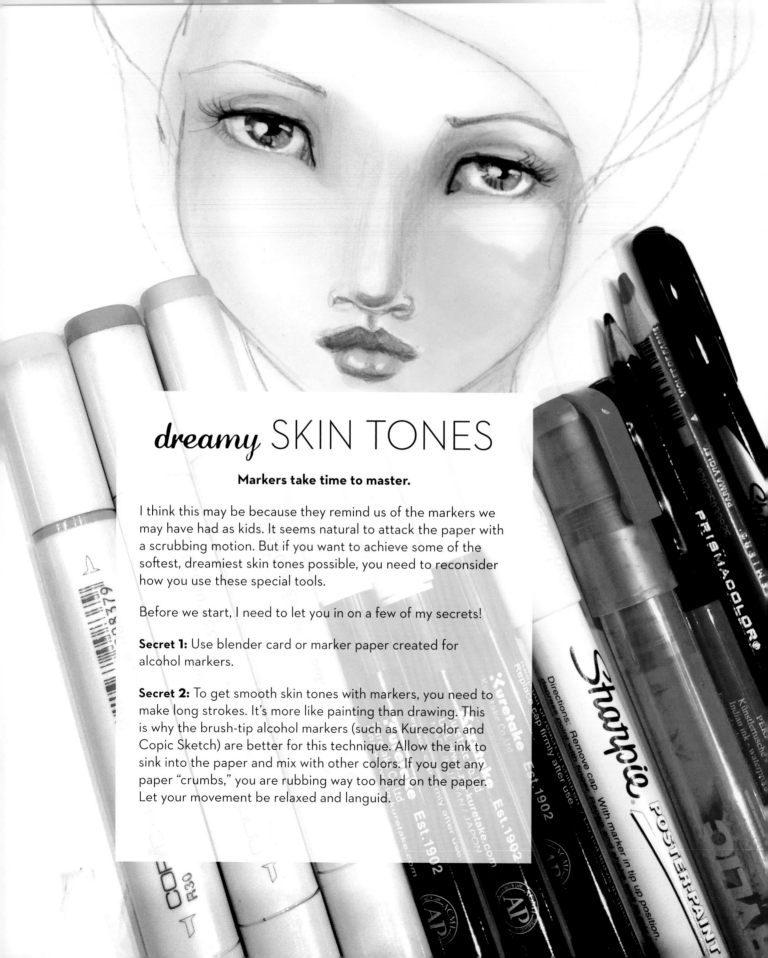

dreamy SKIN TONES

Markers take time to master.

I think this may be because they remind us of the markers we may have had as kids. It seems natural to attack the paper with a scrubbing motion. But if you want to achieve some of the softest, dreamiest skin tones possible, you need to reconsider how you use these special tools.

Before we start, I need to let you in on a few of my secrets!

Secret 1: Use blender card or marker paper created for alcohol markers.

Secret 2: To get smooth skin tones with markers, you need to make long strokes. It's more like painting than drawing. This is why the brush-tip alcohol markers (such as Kurecolor and Copic Sketch) are better for this technique. Allow the ink to sink into the paper and mix with other colors. If you get any paper "crumbs," you are rubbing way too hard on the paper. Let your movement be relaxed and languid.

Legend: Use this key to follow along with the exact tools I use or to help make your substitutions.

① Kurecolor Brush Marker, "Champagne"

② Kurecolor Brush Marker, "Light Bisque"

③ Kurecolor Brush Marker, "Flesh Color"

④ Copic Sketch Marker, "R02 Flesh"

⑤ Copic Sketch Marker, "BV31 Pale Lavender"

⑥ Copic Sketch Marker, "R30 Pale Yellowish Pink"

⑦ Prismacolor Premier CP, "Parma Violet"

⑧ Col-Erase, "Dark Umber"

⑨ Black Sharpie Ex-Fine Pen

⑩ White Waterbased Sharpie Paint Pen

⑪ Montana Acrylic Paint Pen, "Shock Green Light"

⑫ Faber Castell Pitt Pen, "Olive Green"

⑦ Start with a sketch or with a **Jane Girl** stencil.

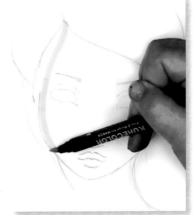

② Drawing with the side of the marker, start at the hairline.

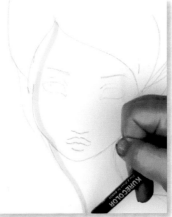

② Take the stroke all the way down to the shoulder. Don't lift your marker.

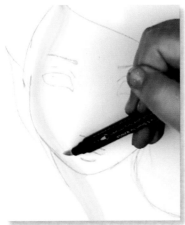

① Repeat with your lighter color.

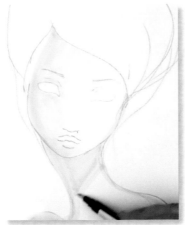

① Shade the neck under the chin.

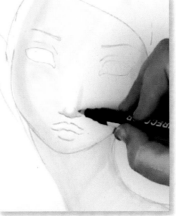

② Add some darker tone at the base of the nose.

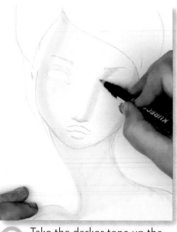

2 Take the darker tone up the side of the nose and eye.

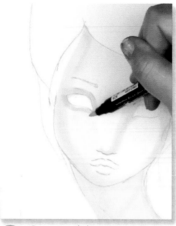

3 Go around the eyes.

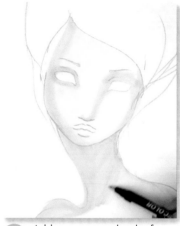

2 Add some more depth of color to the neck.

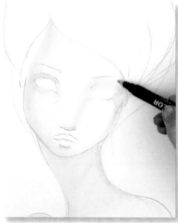

3 Color the temple area with long, overlapping strokes.

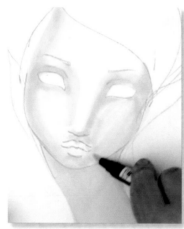

1 Fill in the cheek area on the darker side of the face.

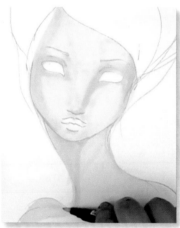

3 Add more color to the neck.

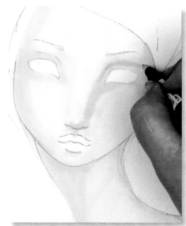

4 Take the darkest of your skin tones and stroke over the eye crease.

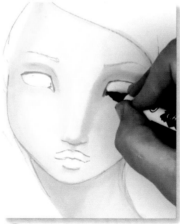

4 Add a little color to the tear ducts.

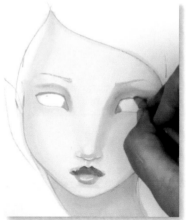

7 Redefine the eyes.

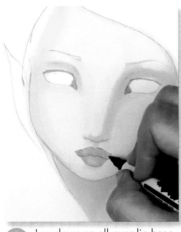

(6) Lay down an all-over lip base.

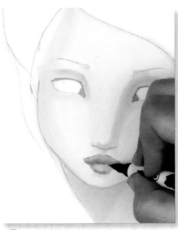

(4) Add the darker lip color between the lips.

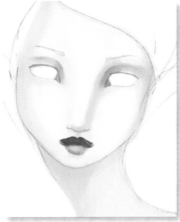

(4) Add more of the darker color to the top lip.

(10) Draw white highlights on the top lip and lower lip.

(5) Define the eye socket with a stroke of your shadow color.

(5) Add the shadow color to the neck.

(3) Define the tip of the nose and nostrils.

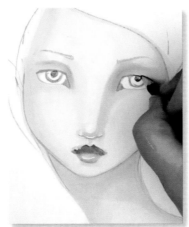

(8) Add pupils to the eyes.

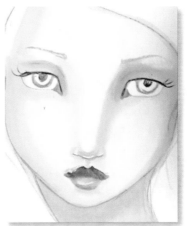

(8) Darken the lash line and add a few eyelashes.

MEAN STREAKS

Your marker strokes can look streaky at first, but be patient and let the alcohol carry the ink into the paper and mix with the other colors before evaporating away. Your marks will blend and settle right before your very eyes! Once you have finished creating your softly toned face, you can cut it out and use it as a collage item in another artwork.

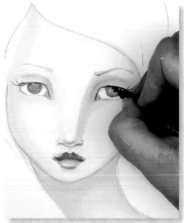

11 Add color to the iris from the pupil to the outer edges.

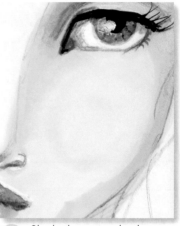

12 Add depth to the top of the iris with a darker eye color.

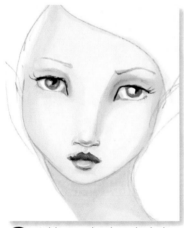

9 Add more depth to the lash line and pupil.

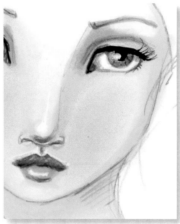

3 Add contouring under the cheekbone to the lips.

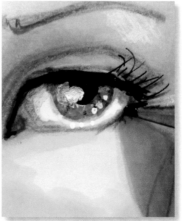

1 Shade the entire cheek area.

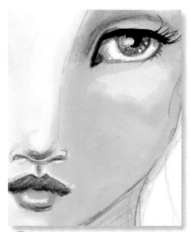

6 Add blush to the "apple" of the cheek. Avoid the cheekbone.

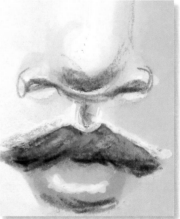

8 Add shadow around the eyeball with pencil.

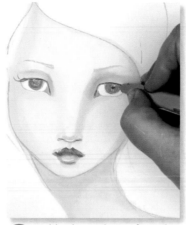

8 Refine the nose and lips with colored pencil.

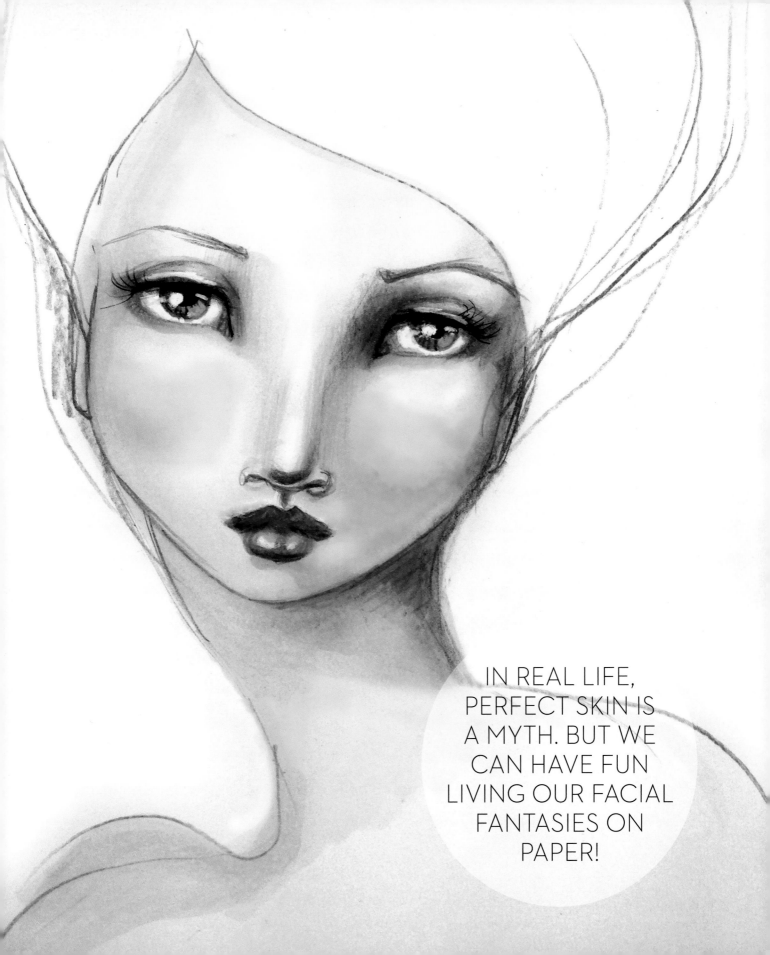

IN REAL LIFE,
PERFECT SKIN IS
A MYTH. BUT WE
CAN HAVE FUN
LIVING OUR FACIAL
FANTASIES ON
PAPER!

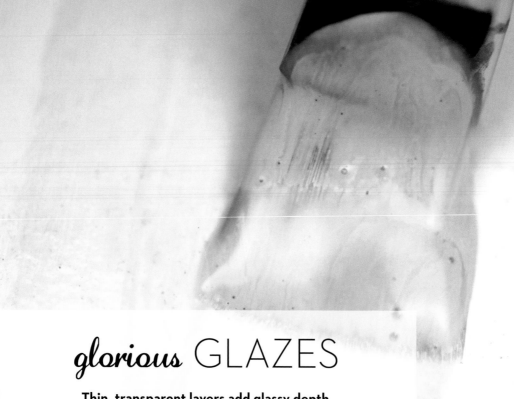

glorious GLAZES

Thin, transparent layers add glassy depth.

You create a glaze when you mix a glazing medium to your acrylic paint. The milky looking medium disperses the paint pigment and dries absolutely clear to leave just the translucent layer of paint behind. It's best to let each layer dry before adding the next, gradually building up a lovely volume.

I like to use Liquitex Matte Medium for my glazes, as most specialty glazes dry glossy and make it difficult to add pencil and other materials. For each layer, mix the matte medium to the paint and apply it over the past layers. The more medium you add, the more gradually you will build your skin tones. You can mix up to 90 percent medium into your paint!

With glazes, the color mixes optically, rather than you having to blend each color. The first few layers look dramatic, but as you add each new layer, the effect is more and more subtle. Expect your work to go through a rather unsettling, ugly-duckling phase, as glazing often doesn't look good until the end!

It's a slow process, but I find it restorative. I paint with glazes when I have extra time and need to paint my cares away.

GLAZE OVER THE DETAILS

Acrylic paint behaves itself best on a dry gesso base, and glazes love a smooth surface. To make it smooth, you can give dry gesso a light sanding with sandpaper.

Remember to let each layer dry before adding the next. If the paint feels tacky, it's not dry.

I am using my favorite Ceramcoat paints throughout this exercise.

A smooth, gesso surface is ideal for building up glazes.

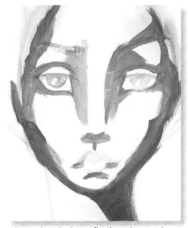

Place the darkest flesh color in the deepest parts of the face (Dark Flesh).

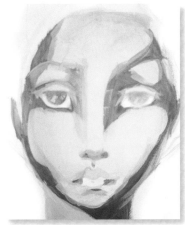

Add a lighter skin tone on exposed areas (Santa's Flesh).

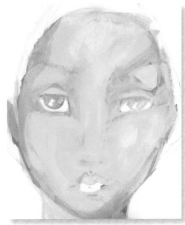

Mix in a good dollop of medium to your mid skin tone (AC Flesh).

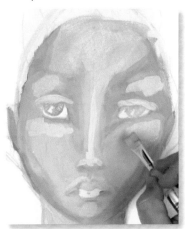

Use a light glaze on the protruding areas: nose, chin, cheekbones, top of lip, and brow bones (Butter Cream).

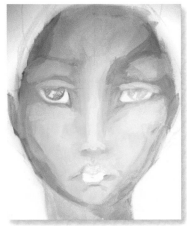

A very thin glaze over the whole face in your lightest skin tone will unify the layers a little (Santa's Flesh).

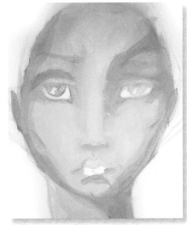

Add a glaze of lilac in the deepest shadow areas (Sweet Pea).

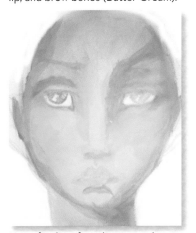

Use a fair bit of medium to make a rosy glaze for the cheeks (Hydrangea Pink).

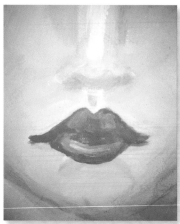

Add lip color in several layers. Use a little of the lip glaze around the eyes, too (Sun Kissed Coral).

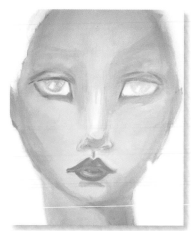

Add several glaze layers in a much-diluted purple to bring definition to the features (GP Purple).

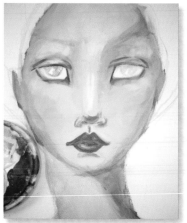

Deepen the darker parts of the face with a darker skin tone glaze (Dark Flesh).

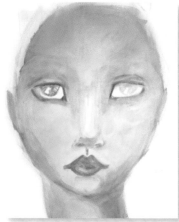

Add a heavily diluted glaze of lilac for extra shadows.

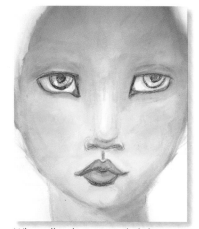

When all is dry, start to lightly re-define details with colored pencil.

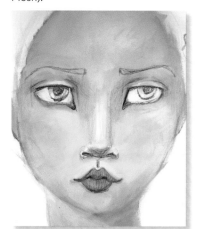

Build up depth with layers of pencil, rather than with pressure.

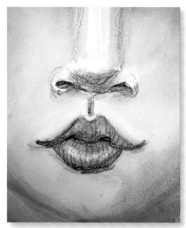

White paint pen on the highest points of the face adds volume.

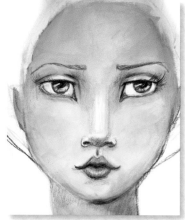

Glazes can still be added and look especially wonderful for iris color.

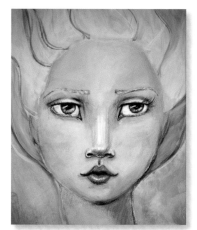

Play with the hair and the background color.

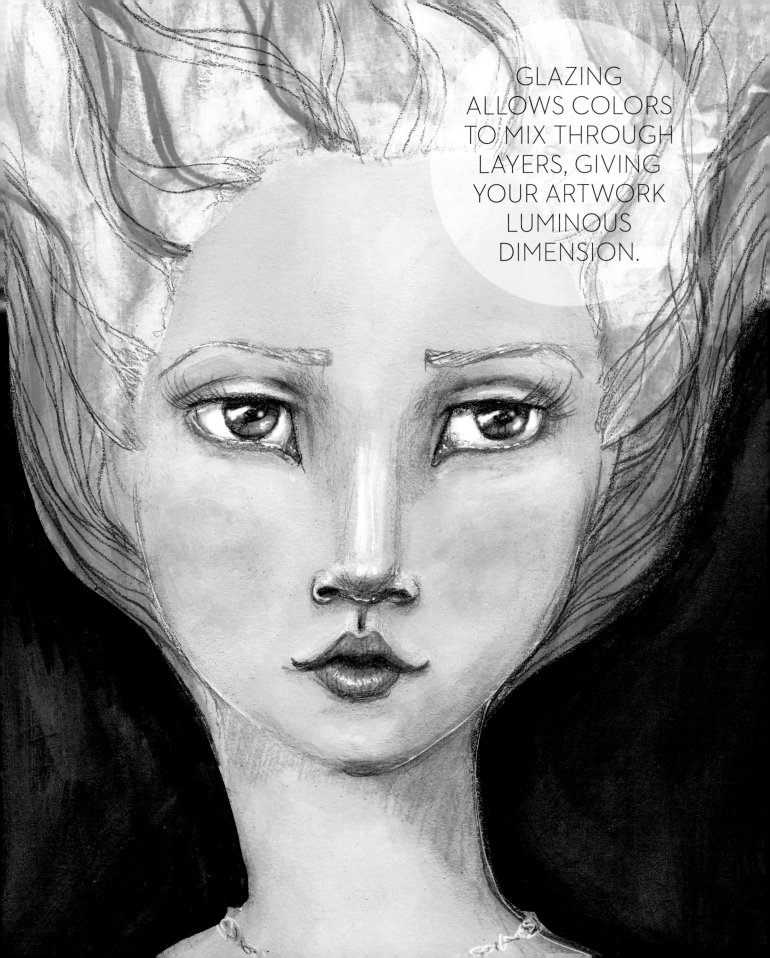

GLAZING ALLOWS COLORS TO MIX THROUGH LAYERS, GIVING YOUR ARTWORK LUMINOUS DIMENSION.

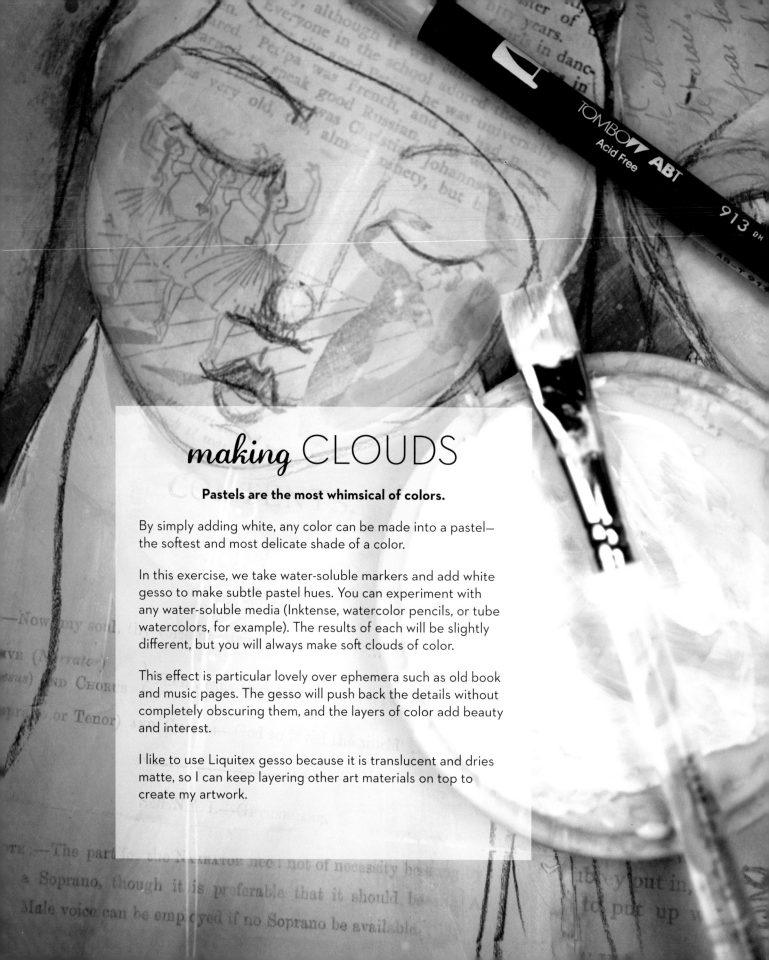

making CLOUDS

Pastels are the most whimsical of colors.

By simply adding white, any color can be made into a pastel—the softest and most delicate shade of a color.

In this exercise, we take water-soluble markers and add white gesso to make subtle pastel hues. You can experiment with any water-soluble media (Inktense, watercolor pencils, or tube watercolors, for example). The results of each will be slightly different, but you will always make soft clouds of color.

This effect is particular lovely over ephemera such as old book and music pages. The gesso will push back the details without completely obscuring them, and the layers of color add beauty and interest.

I like to use Liquitex gesso because it is translucent and dries matte, so I can keep layering other art materials on top to create my artwork.

PAPER DOLLS

I love to alter old books to use as journals. As part of that process, the book's pages are removed and I add them to my ephemera stash. I also have old exercise books from French schoolchildren in the '40s that I found in Parisian markets. I used pages from both of these sources, as well as some music sheets, to create simple paper dolls.

Draw or trace simple face and body shapes on ephemera and cut out.

Play with the paper dolls designs and page composition.

When you have settled on a composition, create a lively background.

Once the paint is dry, glue the dolls down with matte medium.

Gather your water-soluble supplies. Tombow markers are one suggestion.

Place blocks of color with the markers over the dry matte medium.

A translucent, milky wash is created with gesso and matte medium.

Use the milky wash to blend the color marker.

STORY TIME

You can use the following process to build many layers. Lay down some color and blend it in with your brush. This adds soft color in interesting swathes, and it also fades the detail in the ephemera into the background, so you can create something new.

Just be sure to avoid any acrylic on your marker tips, as that will ruin them if not wiped off.

Move between the dolls for each layer so you give the paint time to dry.

Layer new colors and mix with gesso to create lovely mixes.

Create an interesting combination of warm and cool colors.

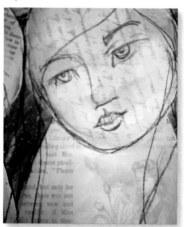

When everything is dry, you can start drawing in your faces.

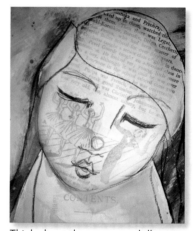

Think about the way your dolls are relating to one another.

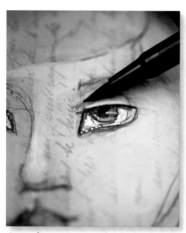

One of my most used supplies are my lilac Tombows. They are perfect for soft shadows.

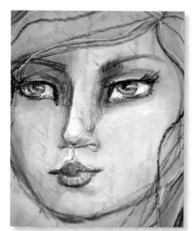

You can add definition to the features and still the collage peeks through.

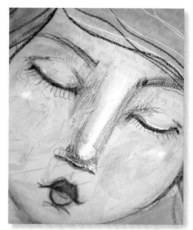

A rosy pink wash for cheeks adds youth and innocence.

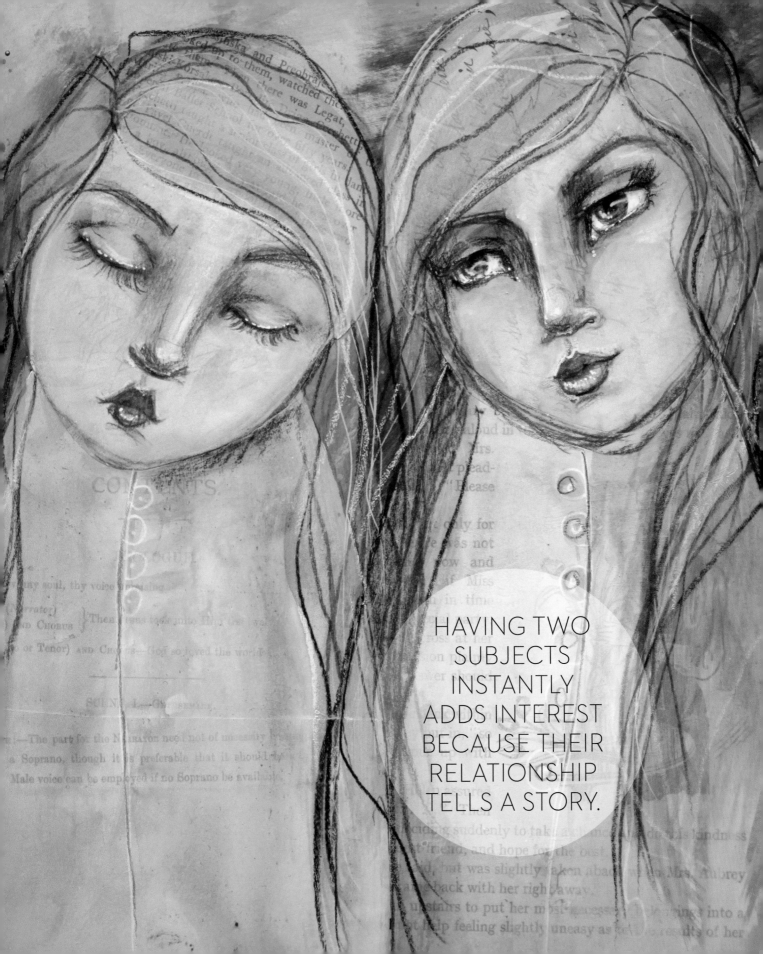

HAVING TWO SUBJECTS INSTANTLY ADDS INTEREST BECAUSE THEIR RELATIONSHIP TELLS A STORY.

STAY *free*

I created this drawing as a demonstration for an in-person workshop. As you can see, the pencil marks are loose and imperfect. I think this gives artwork a carefree look!

I started the page by scribbling with some Gelato pastels here and there. Then I mixed the pastels with gesso to create a lively and matte background.

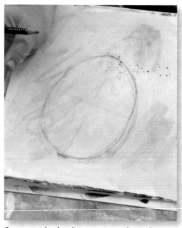

Start with the basics in colored pencil (Parma Violet).

Refine the details to get a feeling for the person you are drawing.

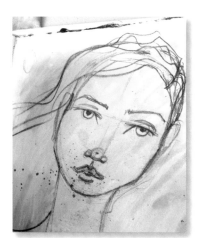

Let your lines stay relaxed to create that feeling in the drawing.

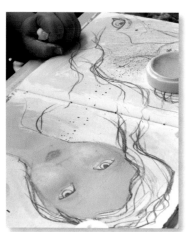

Cover the face with matte paint. The pencil will still be easily visible.

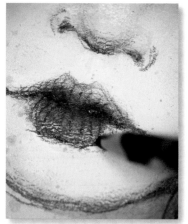

Add a dab of Red Royal dauber and further definition with colored pencil.

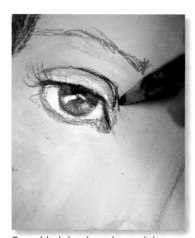

For added depth to the eyelid crease, use a black All pencil.

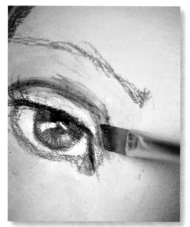

Blend the All pencil with water for the look of soft, deeply set eyes.

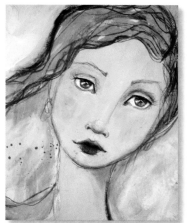

Add hair and eye color with a Tide Pool dauber and water.

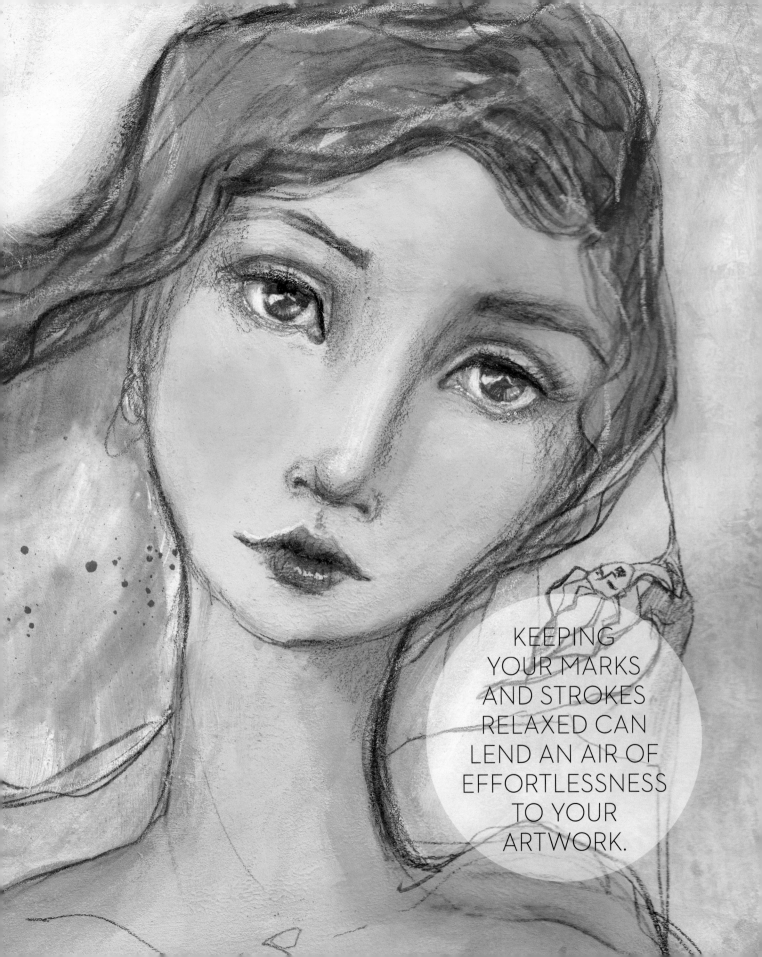

KEEPING YOUR MARKS AND STROKES RELAXED CAN LEND AN AIR OF EFFORTLESSNESS TO YOUR ARTWORK.

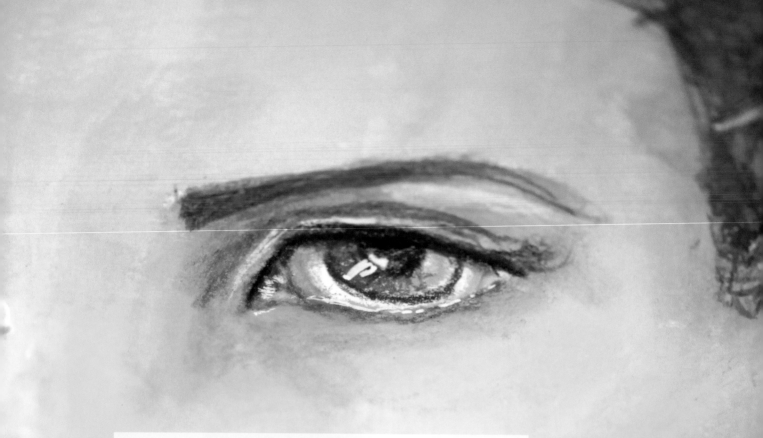

very CHEEKY

Using a painterly style to build volume

A painterly style is all about leaving visible brushstrokes. It's pleasing because it leaves something to the viewer's imagination and we can see the hand of the artist more plainly. Painting in this style is fun because it allows for the impulsive use of color and an unrestrained painting manner!

In this process, you dramatically overdo the initial lay down of colors, as the second stage will bring them back to a softer look. If you love the strong colors you create, and don't want them to be toned down with gesso, you can just add water or matte medium.

I used Faber-Castell Gelatos, but any water-soluble pastel or pencil works in exactly the same way.

TURN THE OTHER CHEEK

Drawing a turned face takes a bit of practice. The main thing that changes as the head turns is the chin and nose become more prominent.

To draw the features on the turned side, you simply squeeze them into the smaller space. You can still draw all the detail, just bunch it up.

Follow along with me and practice—you'll get it!

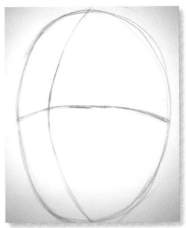

To draw a turned face, start with the **Latitude and Longitude Lines** from chapter two.

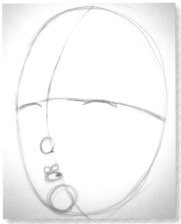

Draw the ball of the nose and chin on the turned away side of the face. Trust me, this works!

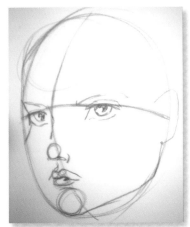

Now you can add the features of the face.

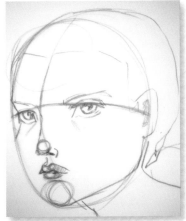

Add more details when you are happy with the feature placement.

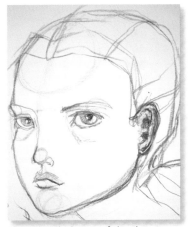

For a detailed view of the drawing, look back to "The Ears Have It" in chapter three.

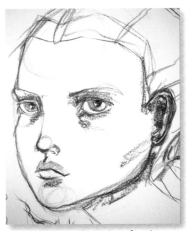

Use a dark purple Gelato for the deepest shadows.

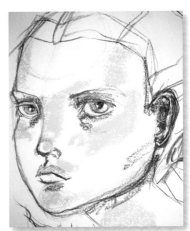

For the medium skin tone, scribble with a Peach Gelato. Leave the high points of the face white.

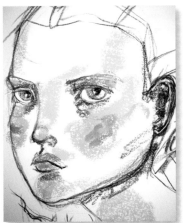

Add two pinks for cheeks and lips.

MIX IT UP

To keep the painterly look, you need to resist blending everything. If you can see chunks of color and the pastel and colored pencil lines through the paint, all the better.

Once the pastel and gesso mix is dry, you can add definition with the pencils, more pastels, paint, or whatever takes your fancy.

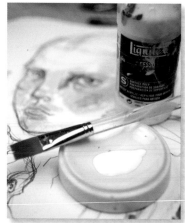

For the next stage, you will need a little gesso on your paintbrush.

Use the gesso to mix the Gelato colors.

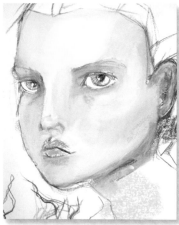

You may need to wash your brush in between major color changes.

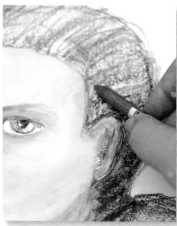

For the hair, I use several shades of brown and butterscotch.

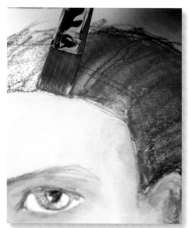

Activate the pastel with matte medium for a translucent effect.

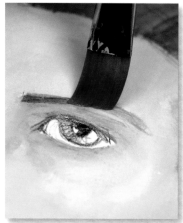

It's important to integrate the hair color into the face.

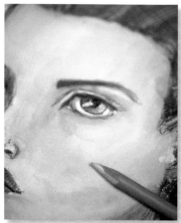

Once it's dry, the painted surface can be drawn on with CP.

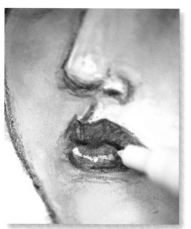

For defining touches, use CP in Dark Umber and a white paint pen.

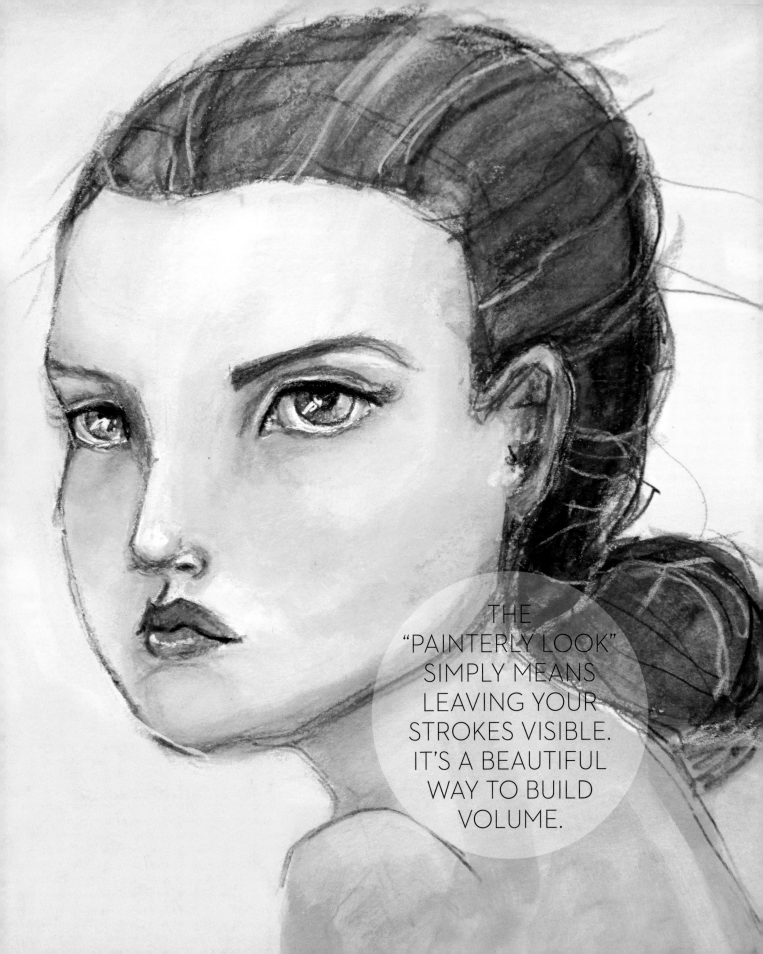

THE "PAINTERLY LOOK" SIMPLY MEANS LEAVING YOUR STROKES VISIBLE. IT'S A BEAUTIFUL WAY TO BUILD VOLUME.

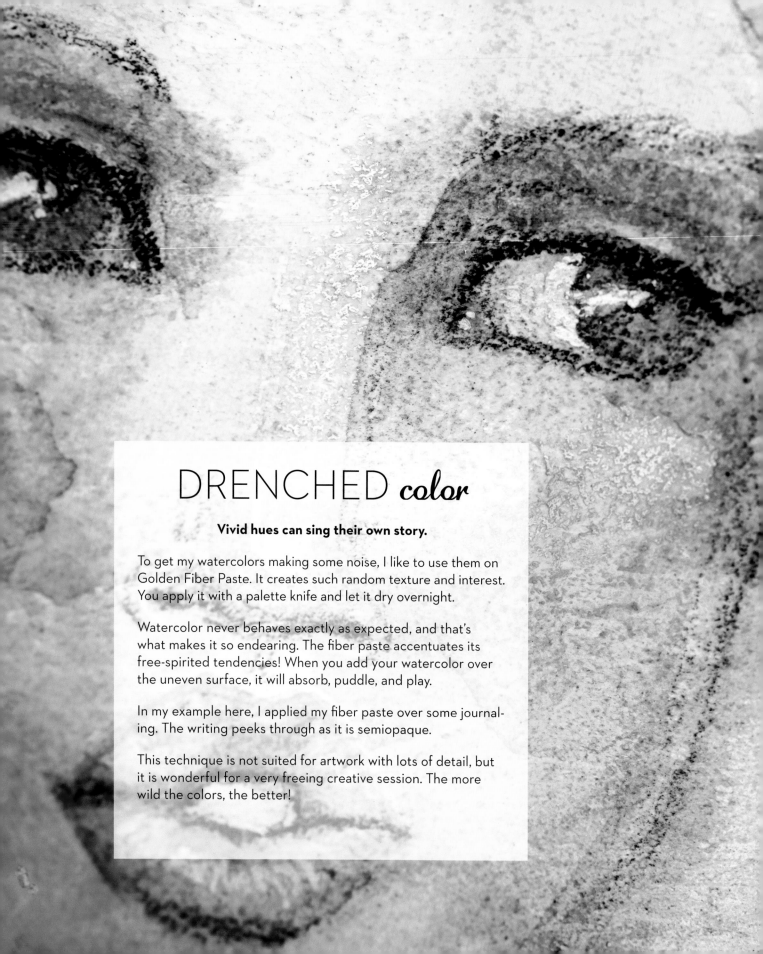

DRENCHED *color*

Vivid hues can sing their own story.

To get my watercolors making some noise, I like to use them on Golden Fiber Paste. It creates such random texture and interest. You apply it with a palette knife and let it dry overnight.

Watercolor never behaves exactly as expected, and that's what makes it so endearing. The fiber paste accentuates its free-spirited tendencies! When you add your watercolor over the uneven surface, it will absorb, puddle, and play.

In my example here, I applied my fiber paste over some journaling. The writing peeks through as it is semiopaque.

This technique is not suited for artwork with lots of detail, but it is wonderful for a very freeing creative session. The more wild the colors, the better!

Prepare a page with the fiber paste. Gather your favorite watercolors. I am using my Peerless Palette.

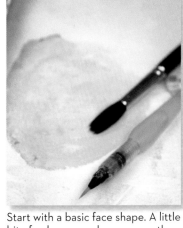

Start with a basic face shape. A little bit of color goes a long way on the fiber paste.

Picking up touches of color, loosely create hair and flowers.

Keep your palette to warm or cool colors to avoid making mud.

Once the watercolor is dry, you can start to draw in some details.

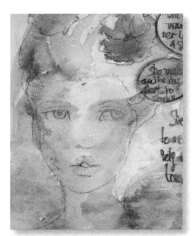

Think about the background, too. I used cool colors as a contrast.

Squeeze the watercolor from your paintbrush to add random splashes.

You can drench the fiber paste with a lot of water to create lovely effects as it dries.

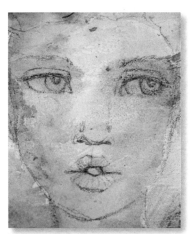

Puddle some darker color for eye sockets to give the face depth.

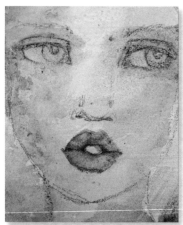

Use a vivid pink for the lips and around the eyes. This will make the iris color really stand out!

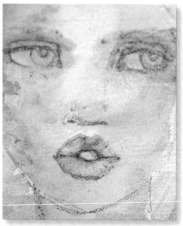

To tone the lips down, add a little more water and blot if needed.

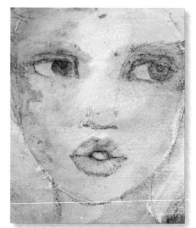

Add color to the iris. This is a good time to bring in a background color to the face.

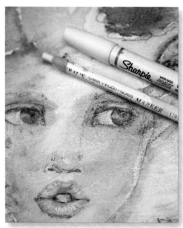

White pens and China markers work beautifully for highlights.

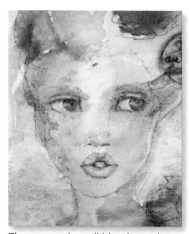

The watercolor will bleed into the white paint pen, so you may need several layers.

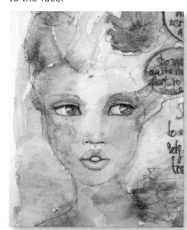

Wash in more color for the cheeks.

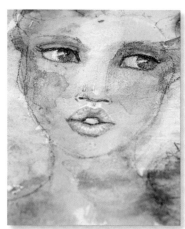

A black China marker is perfect for the pupils and lash line.

With all that color drama, you can be adventurous with your details.

Add small details with watercolor pencils and blend them in with water.

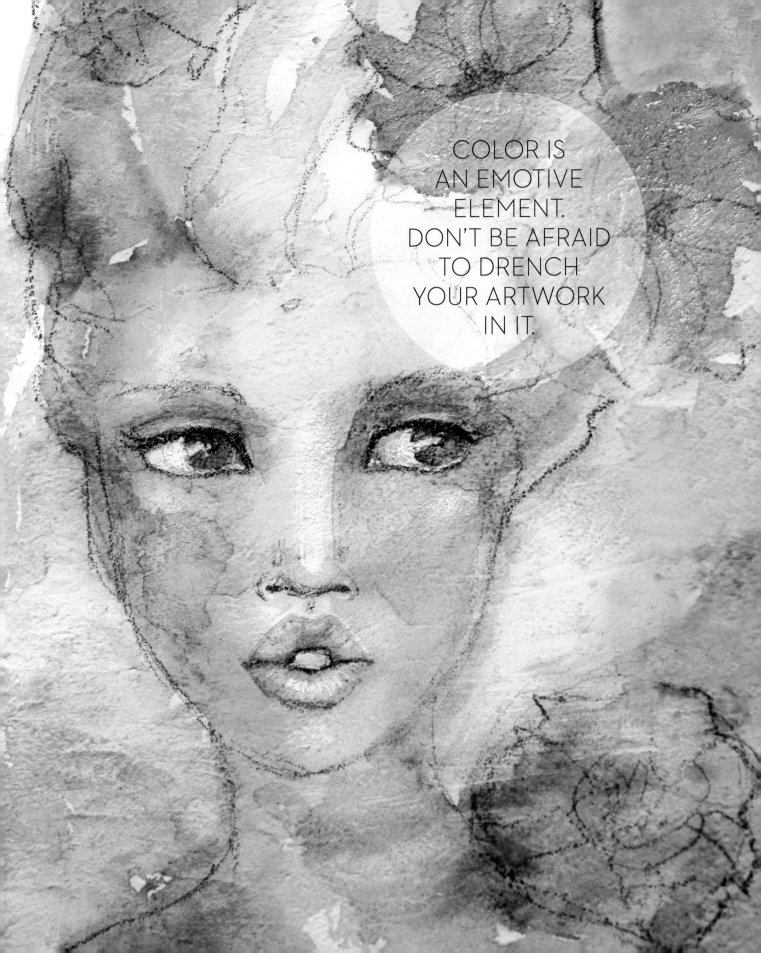

COLOR IS
AN EMOTIVE
ELEMENT.
DON'T BE AFRAID
TO DRENCH
YOUR ARTWORK
IN IT.

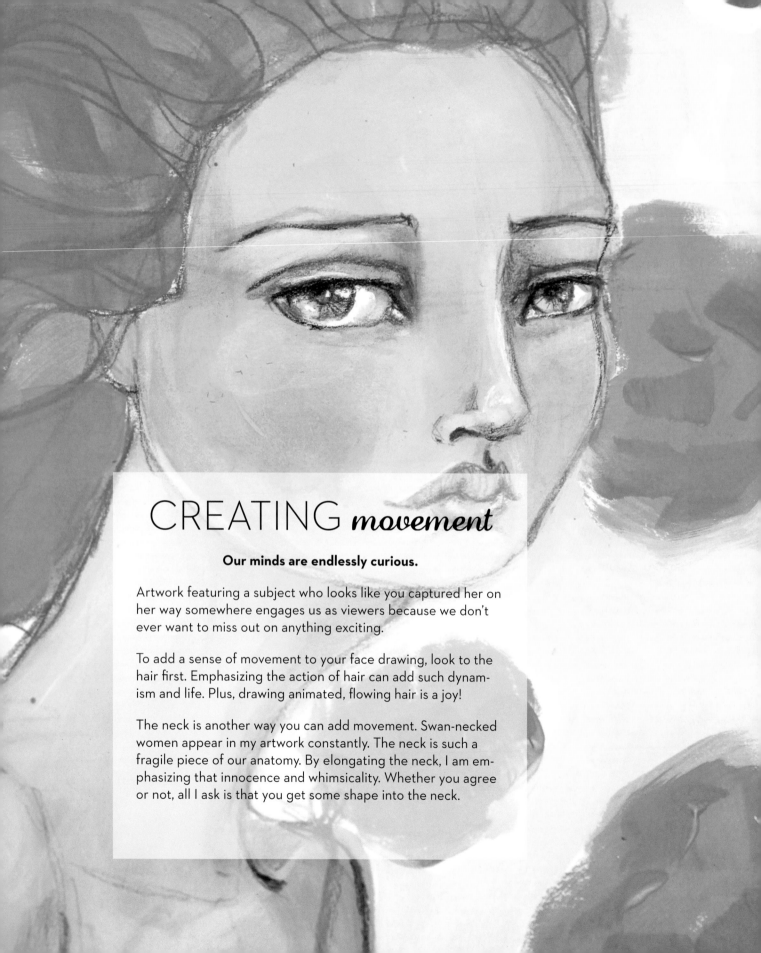

CREATING *movement*

Our minds are endlessly curious.

Artwork featuring a subject who looks like you captured her on her way somewhere engages us as viewers because we don't ever want to miss out on anything exciting.

To add a sense of movement to your face drawing, look to the hair first. Emphasizing the action of hair can add such dynamism and life. Plus, drawing animated, flowing hair is a joy!

The neck is another way you can add movement. Swan-necked women appear in my artwork constantly. The neck is such a fragile piece of our anatomy. By elongating the neck, I am emphasizing that innocence and whimsicality. Whether you agree or not, all I ask is that you get some shape into the neck.

GET A MOVE ON

In this exercise, all of your creative decisions can add action to your artwork.

I find that drawing lines that show movement is best achieved by relinquishing control of my tools, so I hold them further back. I let my marks sweep and flow.

That extra energy can certainly transfer through the paint and pencils to paper!

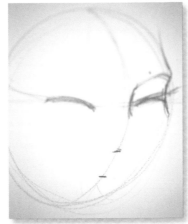

As always, start by "seeing who falls out of the pencil."

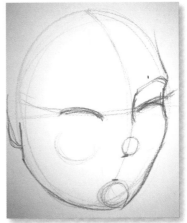

Details are built up by placing the ball of the nose, chin, and cheeks.

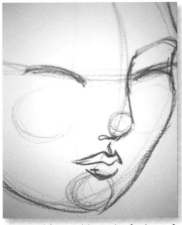

A turned face adds to the feeling of movement.

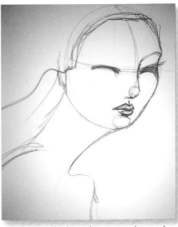

It's the neck that shows us this girl is determined to move.

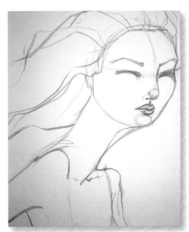

The hair is blowing back in her wake. Note the curved lines.

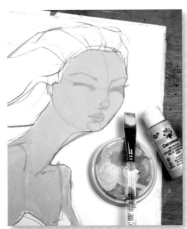

Block in the face with a flesh-tone matte paint.

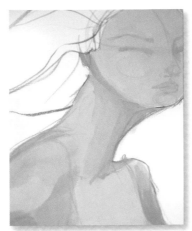

With a darker tone, mark in the shadows to follow her movement.

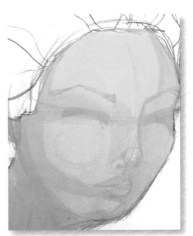

Even with several layers, you can see your sketch through the paint.

MOVING ON

For the next stage, the paint must be bone dry. Because this piece is about movement, I give my painting life by leaving my brushstrokes and pencil lines visible. This adds movement everywhere.

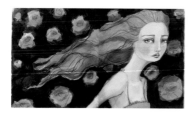

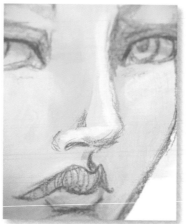

Using the **Guide Lines** of the sketch, create more detailed features.

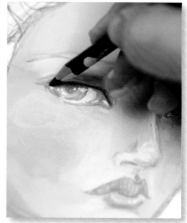

Flesh out the face with more paint in several glazes.

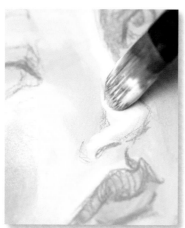

For features that want to pop out, use a watery mix of gesso.

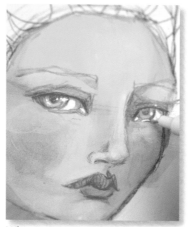

White paint pen makes the whitest whites really come alive.

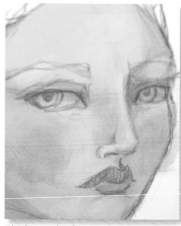

An indigo pencil adds depth in the lash line.

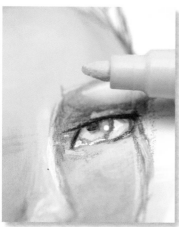

A cream paint pen makes the whites of the eye and highlights shine.

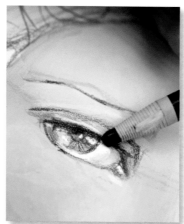

A black China marker has an appealing and imperfect look for details.

Paint the hair from scalp to tips, following the flowing motion.

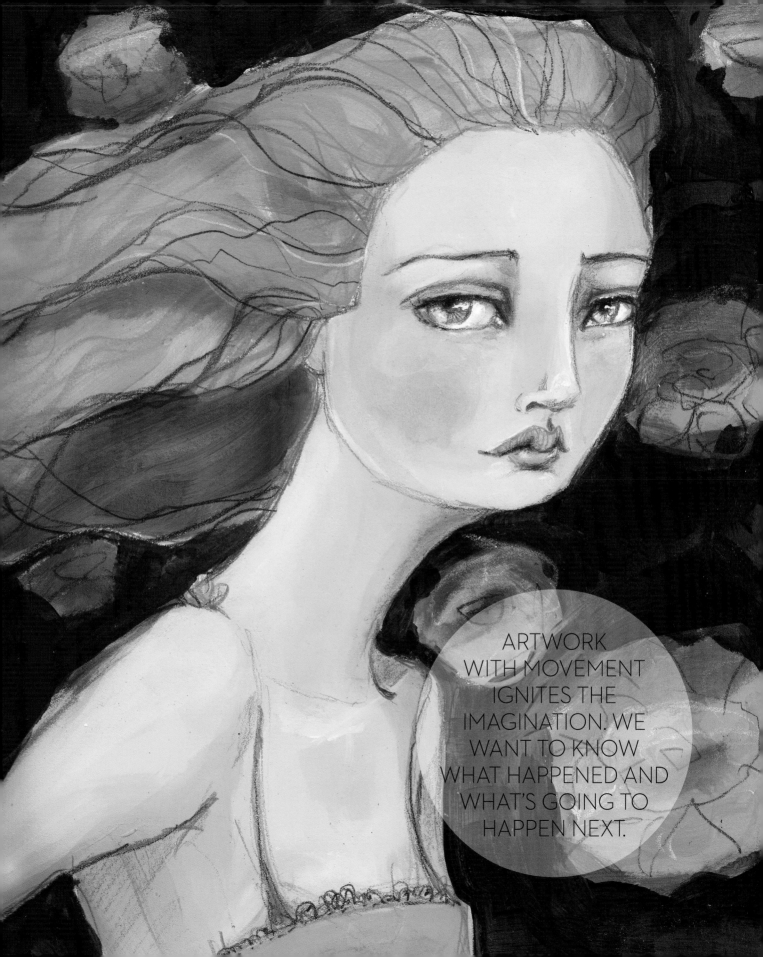

ARTWORK
WITH MOVEMENT
IGNITES THE
IMAGINATION. WE
WANT TO KNOW
WHAT HAPPENED AND
WHAT'S GOING TO
HAPPEN NEXT.

HOT *mess*

Spray inks are messy, chaotic, and FUN!

I often use spray inks at my art retreats because I love watching people have a ball creating chaos on their pages. The effects are hard to predict, so they are wonderful for a bit of relaxing and happy art.

Ink sprays make wonderful backgrounds because they can fill up an area so quickly but never look boring. They come in an ever-expanding array of brands and formulations and delightfully rowdy colors. You can also mix all the brands and make your own spray inks.

I think of all spray inks as falling into two categories: permanent and water soluble. Both have their virtues, but I do prefer the permanent ones because I can layer them. Mister Huey's, sprINKlers, and Fireworks are examples.

In this lesson, we let off some creative steam with spray inks. Find inspiration in the chaos and create a whimsical face!

STEP BY STEP

I used all warm and fiery colors (reds, yellows, oranges, and pinks), as well as a little bit of purple to jazz things up. Purple is a strange creature because it is made from warm red and cool blue, so it is neither hot nor cold. It just is what it is—beautiful!

By sticking to either warm or cool colors, you can keep everything vibrant.

Here's a lovely selection of spray inks!

Sprays behave very differently on every surface. This is the ink on paper.

This is the spray on a matte acrylic surface—delicious!

Blow through a straw to get the ink to run over the surface.

If you allow the ink to dry, you can layer the colors.

This is a few drops of gesso with some ink sprayed onto it.

Blow through a straw and watch the fantastic patterns the ink creates!

Letting the concoction dry before adding another color adds complexity—and mess!

LOOKING FOR LIFE

Once the inks are dry, it's time to draw something out of the wild color frenzy!

The challenge is to bring out a face, but keep parts of the background visible.

This process is like looking at clouds in a blue sky and seeing what forms they make.

I could see a fairy with wild hair peeking down from the top of the page.

Use a pencil in a contrasting color to make a sketch over the ink.

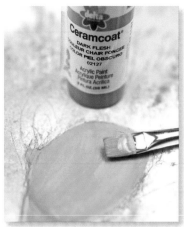

Paint the face with a matte acrylic skin tone such as Dark Flesh.

Sketch out the flow of the hair and incorporate favorite areas of ink.

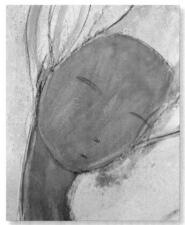

To place the features, it may be easier if the page is turned around.

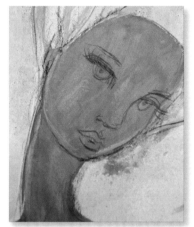

When you are happy with the basics, sketch out the details.

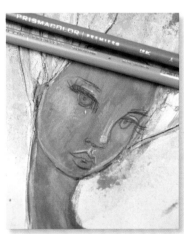

For the cheekbones and highlights, I used Salmon Pink and then Lilac for the shadows.

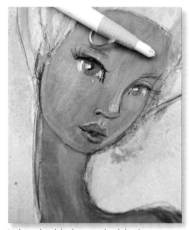

White highlights and a black pen bring out the details.

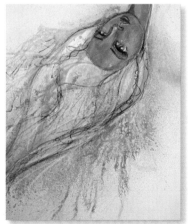

The last step is to make the fairy stand out from her background by painting around her.

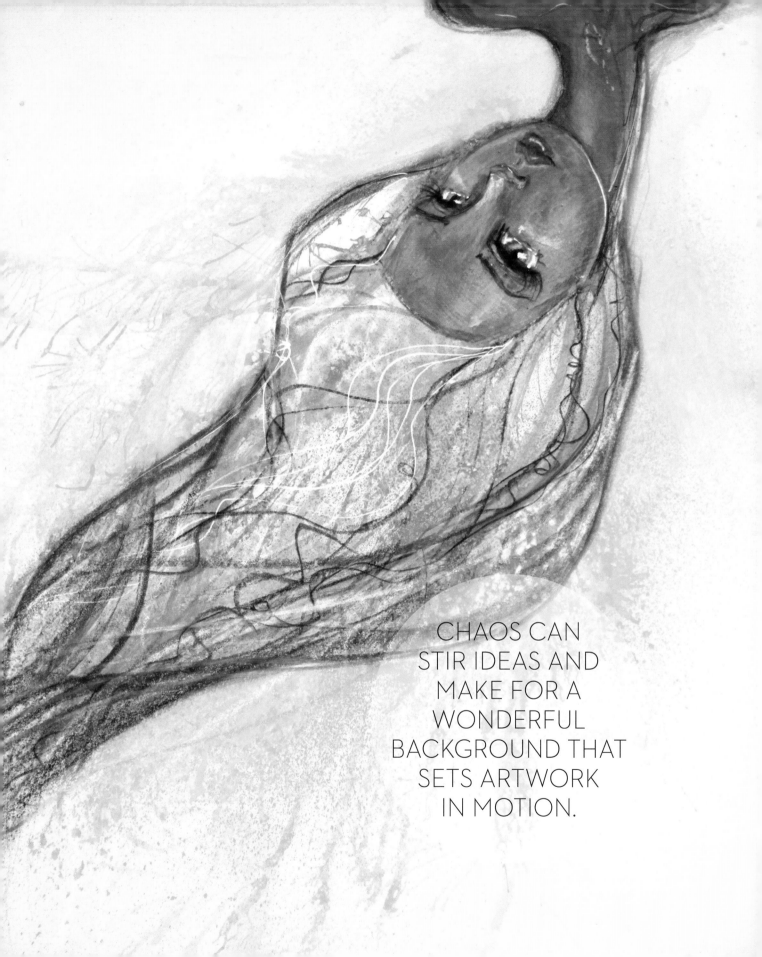

CHAOS CAN
STIR IDEAS AND
MAKE FOR A
WONDERFUL
BACKGROUND THAT
SETS ARTWORK
IN MOTION.

NEON *edges*

Neon is back! Fluorescent materials are fabulous fun, but if they are used without care, they can be overwhelming.

In this technique, you have the pleasure of playing in a bright playground, but end up with a more visually pleasing balance in the final artwork by confining the color to the edges.

Use a combination of neon Daubers, sprays, and paint markers.

Mix them with gesso and matte medium to tone down some areas.

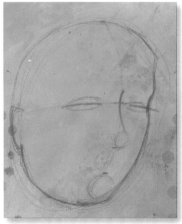

When all is dry, you can create your artwork.

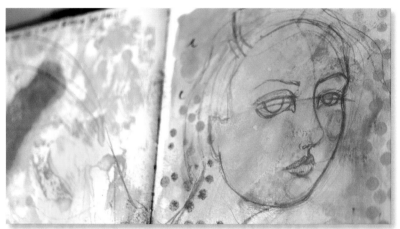

Now you can decide which edges you would like to have in neon. I decided that I wanted neon in the eyes, so I made sure I didn't paint over them.

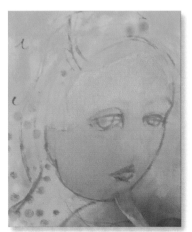

Paint up to the edges, but not over them. You are letting the background peek out in those areas.

A dark background really lets those neon edges glow!

Add your details with pencil or paint. I let the background shine through the eyes as well.

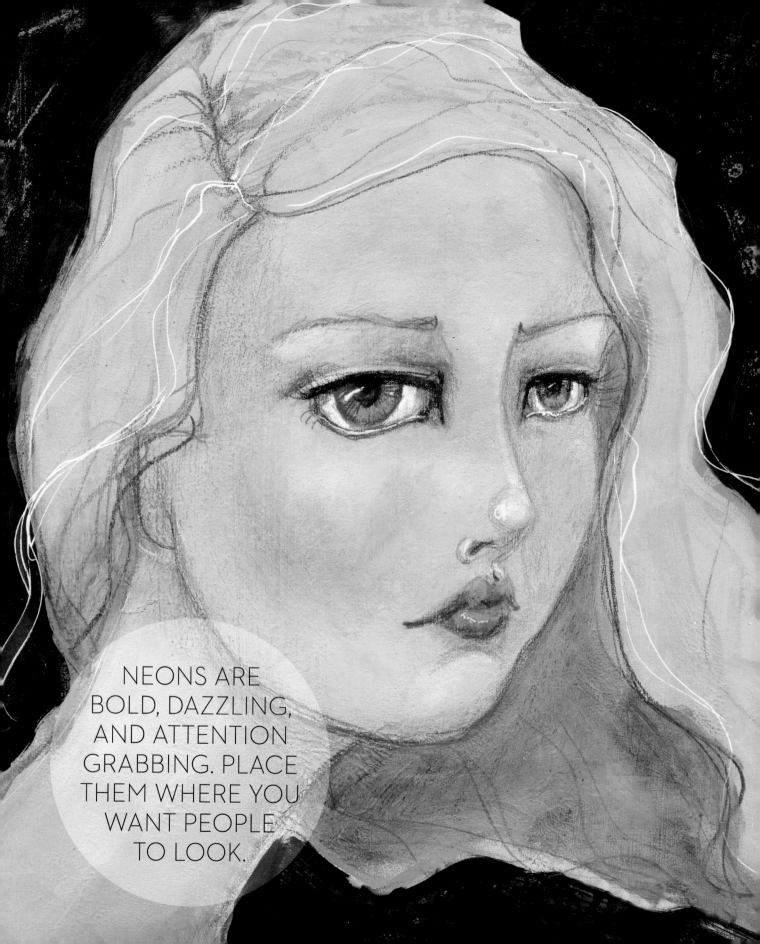

NEONS ARE BOLD, DAZZLING, AND ATTENTION GRABBING. PLACE THEM WHERE YOU WANT PEOPLE TO LOOK.

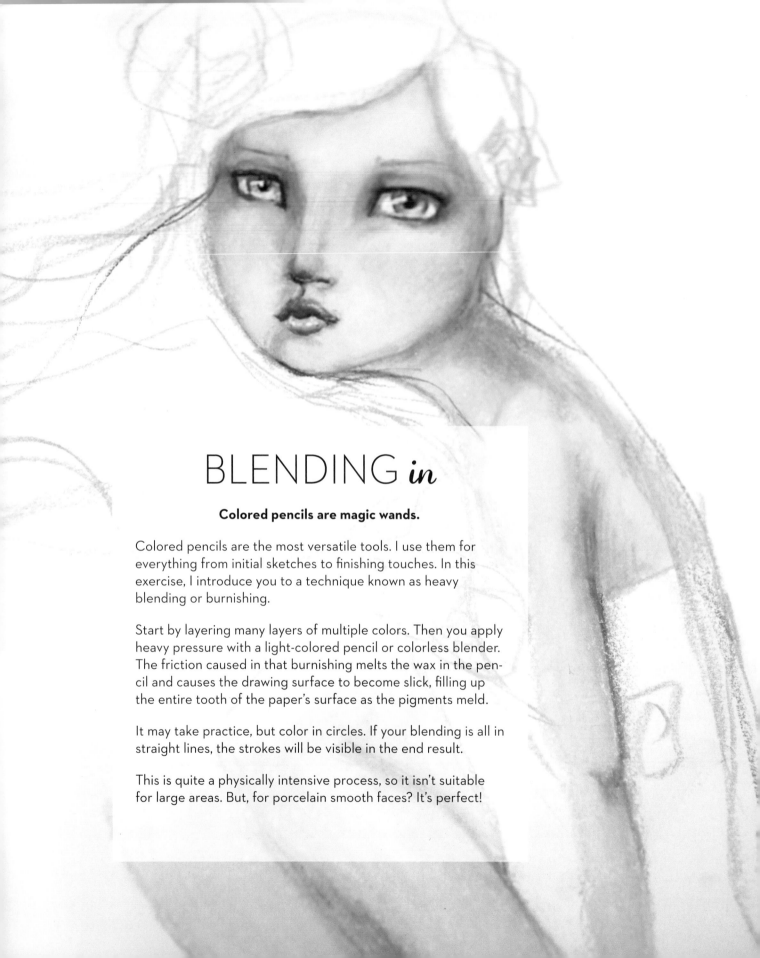

BLENDING *in*

Colored pencils are magic wands.

Colored pencils are the most versatile tools. I use them for everything from initial sketches to finishing touches. In this exercise, I introduce you to a technique known as heavy blending or burnishing.

Start by layering many layers of multiple colors. Then you apply heavy pressure with a light-colored pencil or colorless blender. The friction caused in that burnishing melts the wax in the pencil and causes the drawing surface to become slick, filling up the entire tooth of the paper's surface as the pigments meld.

It may take practice, but color in circles. If your blending is all in straight lines, the strokes will be visible in the end result.

This is quite a physically intensive process, so it isn't suitable for large areas. But, for porcelain smooth faces? It's perfect!

BLENDING THE RULES

You can try this technique with any brand of colored pencil, but the best results will be with Prismacolor Premier. This is because the pencils have such a high concentration of pigment and wax.

A smooth paper is ideal. I use Strathmore Bristol and Fabriano Artistico in Hot Press for porcelain-smooth results.

Start your sketch with Light Peach.

Layer in the deep parts of the face with Peach.

Parma Violet is wonderful for shadows.

Build up the cheeks and lips in Blush.

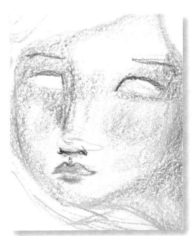

Start to define your features in Dark Umber.

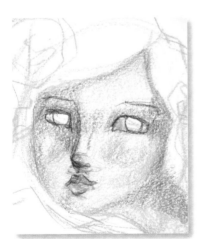

Continue adding details to the features.

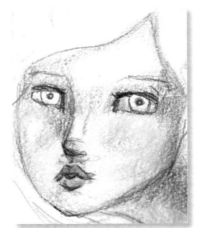

Use black for pupils and lashes to bring the features into focus.

Don't forget the rest of the figure if you have included it.

THE BLENDER

My personal preference is to use White, Cream, and Eggshell as my blenders, but you can also use a colorless blender. The only way to find your favorite is by experimenting.

As you blend, be on the lookout for small crumbs of pencil that can be dragged in to your blending, making an unwanted streak of color.

Apply your cream pencil over the color layers with firm pressure. Move in small circles.

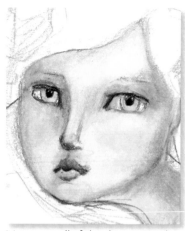

Move over all of the skin, section by section.

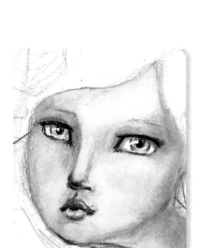

White paint pen highlights on the eyes, lips, and nose add sparkle.

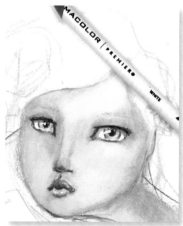

White pencil burnishing over cheekbones will make them pop out.

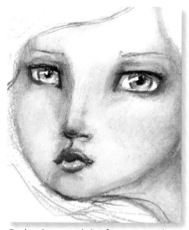

Go back around the features with various pencils to add depth.

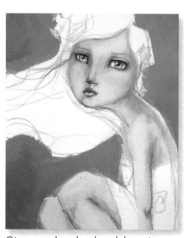

Give your hands a break by using paint for the background.

Matte paint makes a great contrast to the shine of the burnished areas.

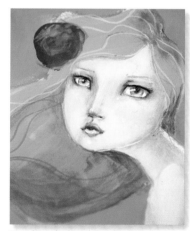

Finish with details in the hair and figure.

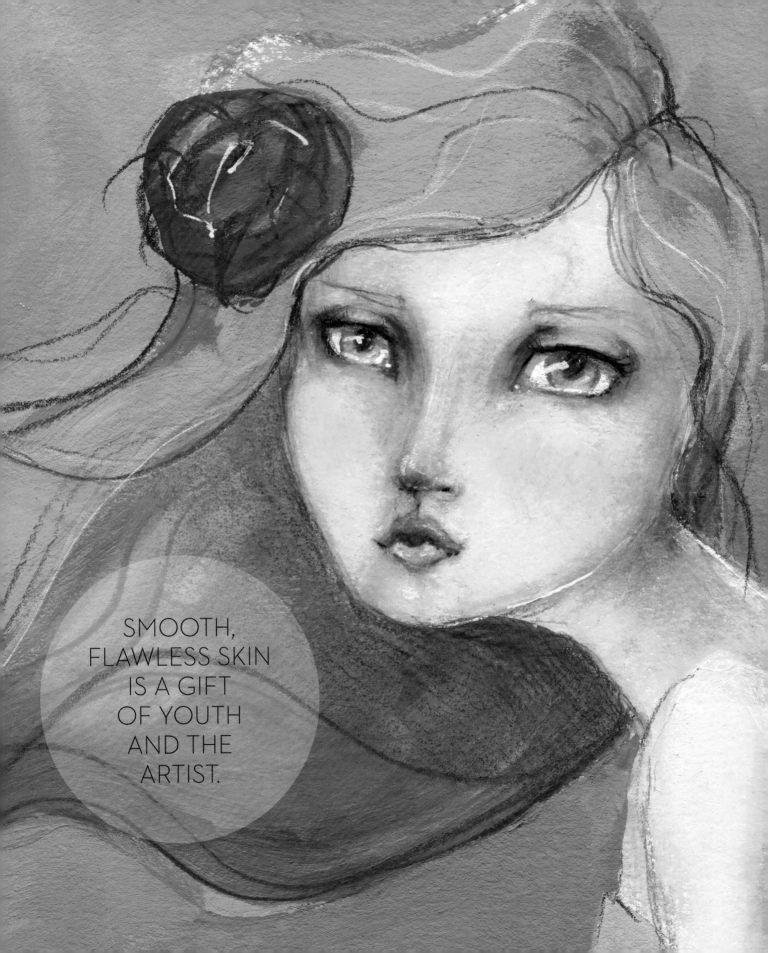

SMOOTH,
FLAWLESS SKIN
IS A GIFT
OF YOUTH
AND THE
ARTIST.

TRUST *the* MESS

My Personal Message for You

"Trust the Mess" is my mantra. It means not just accepting mistakes and missteps, but welcoming them because they are simply part of the creative process. I believe, as an artist, you must be prepared to experiment and take creative risks to improve your skills. What holds us back is the fear of doing it wrong. And I am here to tell you, there is no right or wrong in art!

I say, "Trust the Mess" to myself when I need to let go of preconceived notions of where my artwork is heading and just let it unfold. The process of creating is the juicy and joyful part. Naturally, it is going to take time to develop your skills and your own style, and not everything you create will be a masterpiece, but even when you create something you don't like you have learned something.

We often feel the need to achieve something with our time. The joy, freedom, and exhilaration you can feel when you move your pencils and brushes is priceless. If releasing the artist in yourself makes you happy, then that is absolutely enough!

I view this book is a guidepost along your creative path. It's such a pleasure to walk alongside you for a bit. Until we meet in a workshop or in my next book, keep on creating and please, "Trust the Mess!"

xoxox
Jane/Danger

Love what is

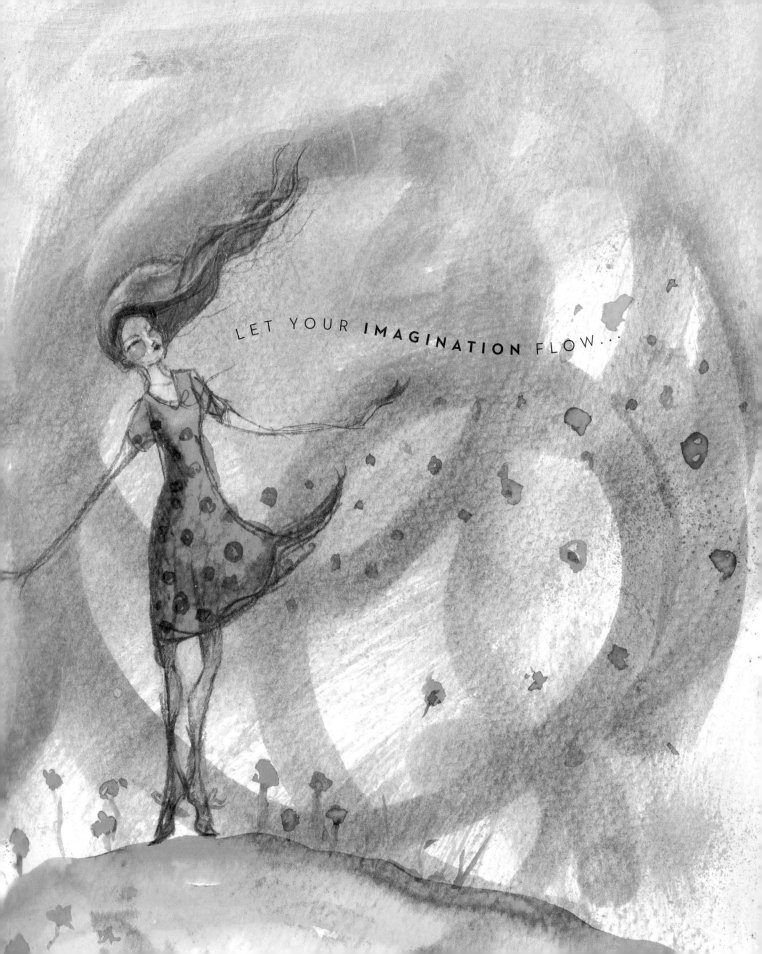

DRAWING and PAINTING

beautiful

FACES

THE *e* COURSE

YOUR *invitation!*

DRAWING *and* **PAINTING**
beautiful
FACES
THE *ecourse*

jane davenport

Would you enjoy developing your skills and artistic confidence even further? If so, you are invited to join the online workshop that Jane Davenport has specifically designed to expand on the techniques in this book. It includes footage of projects from this book coming to life and delving into further detail.

The beauty of online workshops is you get to study at your own pace, at your own convenience, and you can review the materials as often as you need to let each lesson sink in. Plus, you can learn in your pajamas! You can join Jane Davenport's creative community to share your homework and get answers to your questions on drawing and art supplies.

Purchase of the book is a prerequisite for participation in this exciting e-course.

For full details, go to the following website.

WWW.JANEDAVENPORT.COM

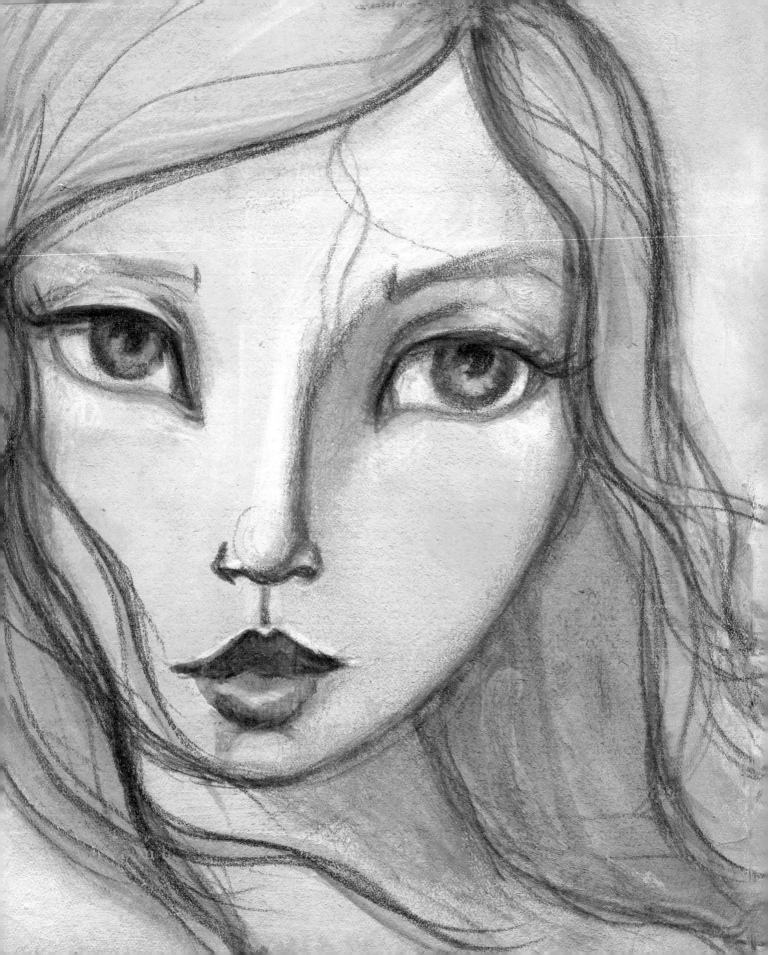

ABOUT THE AUTHOR

Jane "Danger" Davenport is an internationally recognized artist, prize-winning author, and beloved workshop leader. She is based at The Nest, overlooking Byron Bay, Australia, and has koalas in her garden.

Girls' faces feature strongly in Davenport's whimsical work, often with somewhat wistful or melancholy expressions and surrounded by interacting color and nature. Danger's work has been featured in a diverse array of media including major motion pictures.

Davenport started her creative career as a fashion illustrator and the evidence of her Parisian training still lingers in her elongated figures. When Jane sets out to draw, it is rarely with something specific in mind. Instead, she starts with a face and lets her imagination guide the process.

Through her online art schools, publications, and Escape Artist Retreats, Davenport has enabled tens of thousands of creative people from all around the world to embrace their innate artistic selves and accelerate their progression. As a gifted teacher, she is dedicated to making the world a better place, one drawing at a time.

You can keep up with Jane Davenport and discover how she lives up to her nickname on her website, **www.janedavenport.com**

RESOURCES

Online workshops and retreats with Jane Davenport
www.janedavenport.com

Jane Davenport Signature Stencil Series
www.artistcellar.com

Jane Davenport Peerless Watercolors
www.peerlesscolor.com

Art Supplies
www.janedavenportstore.com

A LUCKY MISS

ACKNOWLEDGMENTS

Creating this book was an all-encompassing task. While writing the manuscript, creating the artwork, photographing it all, and designing the book, I also filmed everything for the online workshop! The only reason I didn't get overwhelmed was because of my incredible support system. This was led by my brilliant and beloved husband, Angus, and populated by the wonderful students who became dear friends at my retreats and online.

My eternal gratitude goes to Connie Hozvicka for inviting me to teach that first time. What an incredible door you opened!

Thank you also to Flora Bowley for putting my editor, Mary Ann Hall, and I together and getting this big ol' colorful ball rolling with the wonderful team at Quarry!

Thank you,
Jane Davenport

WWW.JANEDAVENPORT.COM